Carving & Painting
ADORABLE ANIMALS
IN WOOD

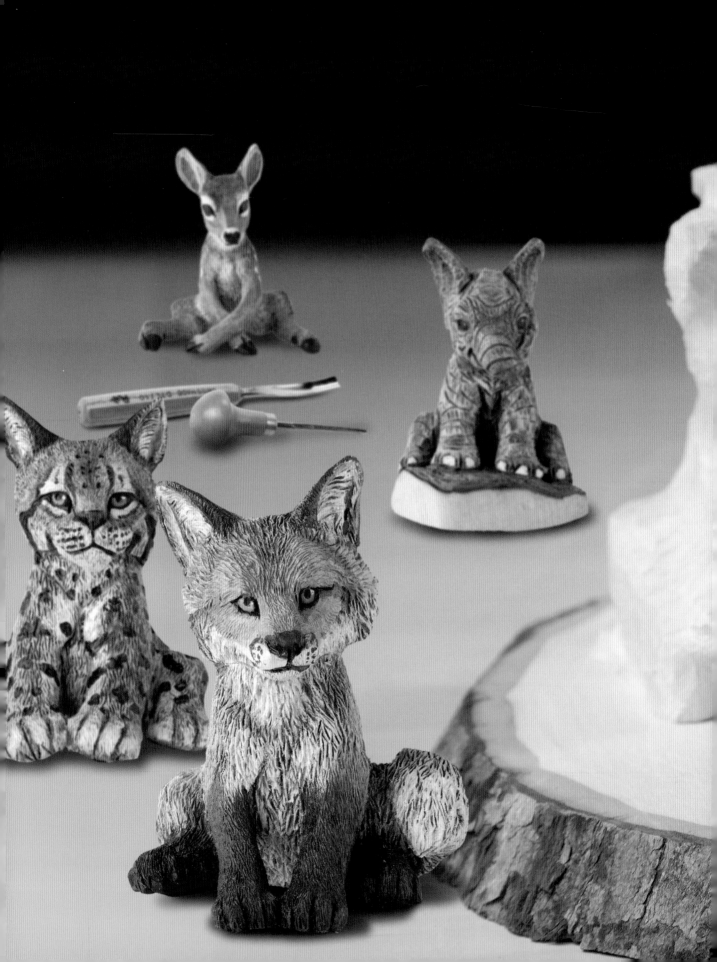

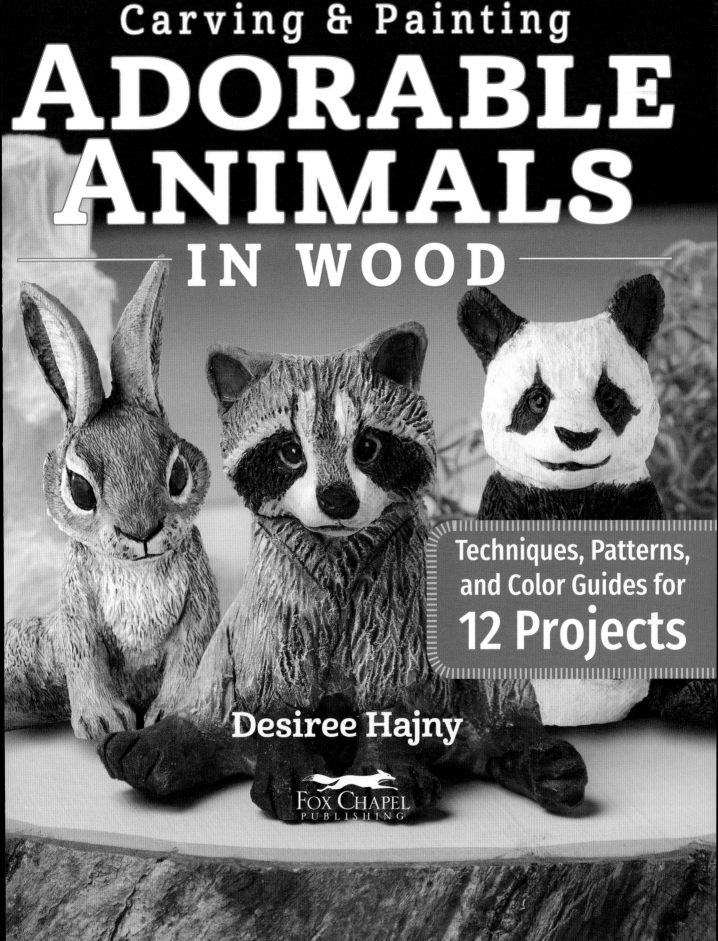

Carving & Painting
ADORABLE ANIMALS
IN WOOD

Techniques, Patterns, and Color Guides for **12 Projects**

Desiree Hajny

FOX CHAPEL
PUBLISHING

Dedication

Through my adult life, I have had the pleasure of having some very special four-legged friends be part of these years. I enjoyed the time with each, but they all also served to teach me some important values:

To Buster, our first dog. He was small in stature but very stubborn. I have always tried to apply this same attitude of stubbornness in achieving the goals I was trying to attain.

To Taffy, a beautiful dog whom we rescued from a shelter. Taffy had been abused, and it took a long time for us to gain her trust. I learned a sense of patience from her and to try to give people a second chance.

To Dottie, our wonderful, amazing dog that adopted us. Dottie had the heart of a lion, and although she had some tough years before deciding to pick us, she lived to the age of almost twenty. I learned to have a bit of tenacity in all aspects of my life, just as she did.

To Norbert, our red-footed forest tortoise. Norbert moved slowly but with a purpose. He taught us patience, not to tackle things in a rash manner, and to enjoy the very simple things in life.

They were all wonderful, important members of our family. They taught us so much, we loved each dearly, and we think of them often.

© 2020 by Desiree Hajny and Fox Chapel Publishing Company, Inc., 903 Square Street, Mount Joy, PA 17552.

Carving & Painting Adorable Animals in Wood is an original work, first published in 2020 by Fox Chapel Publishing Company, Inc. The patterns contained herein are copyrighted by the author. Readers may make copies of these patterns for personal use. The patterns themselves, however, are not to be duplicated for resale or distribution under any circumstances. Any such copying is a violation of copyright law.

ISBN 978-1-4971-0083-1

Library of Congress Control Number: 2020931482

To learn more about the other great books from Fox Chapel Publishing, or to find a retailer near you, call toll-free 800-457-9112 or visit us at *www.FoxChapelPublishing.com*.

We are always looking for talented authors. To submit an idea, please send a brief inquiry to acquisitions@foxchapelpublishing.com.

Printed in Singapore
First printing

Foreword

Have you ever met someone you immediately liked? We met Desiree Hajny in 1991; she was just getting established as a carver when she came to Charlotte, NC, to teach a seminar for the Charlotte Woodcarvers Club. It did not take long to understand that Desi is a true artist and a professional woodcarver as well as a very special teacher. Desi specializes in carving wildlife, and we have watched her develop projects from simple animals to complex designs.

Desi is a happy, outgoing person in love with life, her family, and carving. Her positive attitude and instructional methods enhance the abilities of experienced carvers while allowing even beginner carvers to feel at ease and produce a good complete carving. Beyond carving skills, Desi has excellent woodburning techniques, which, along with her painting skills and in-depth understanding of wildlife anatomy, bring her carvings to life. She has the ability to add expressions to a carving that one can't describe with words.

We have deepened our friendship with Desi and her husband, Bernie, over the course of more than twenty years and have enjoyed hosting them in our home for seminars and carving shows. Desi's carving seminars are popular and fill up quickly. People know that she has both true artistic skills and a passion for helping others to discover their own artistic talents.

This book will thoroughly show you many ways to create and improve your carving, burning, and painting techniques. You'll see just how detailed and thought out all of her illustrations are. Desi's desire is for each person who picks up a carving knife to have a good experience along with success in carving, just as she has. She is simply that kind of person, sharing the love of art through her carvings.

Happy carving from a woodcarver and his wife!

Bill and Judy Dominick
Charlotte, NC
Bill is a charter and lifetime member of the Charlotte Woodcarvers Club.

Contents

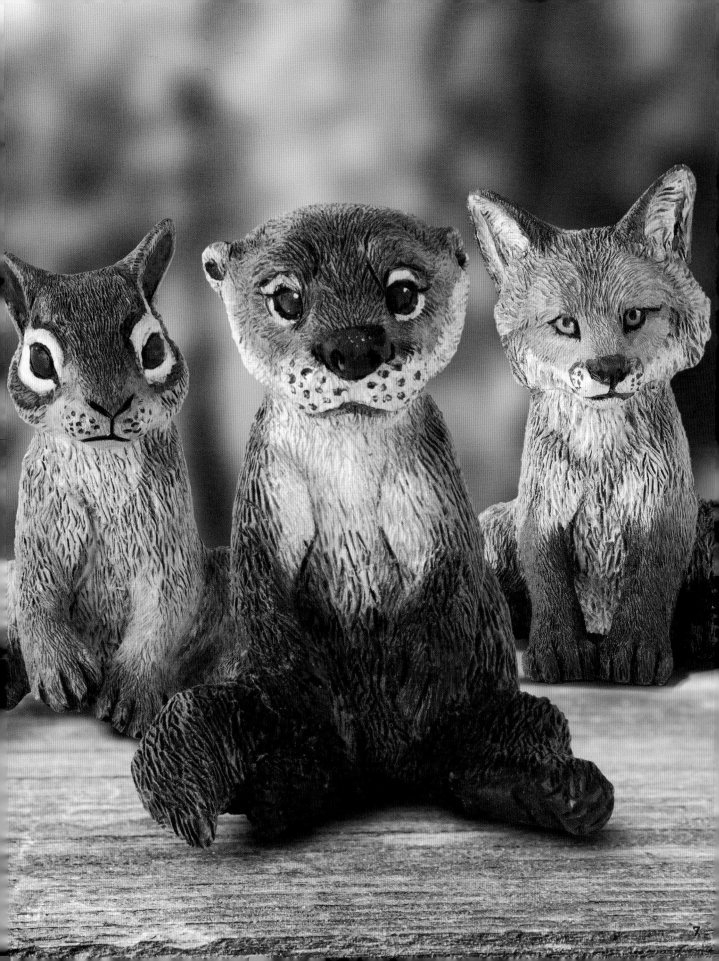

Introduction: A Life of Carving

"Everything you do in life is cumulative." While teaching art to high school students, I heard these sage words of advice from the wife of a fellow teacher. How true they have been in my journey through the past forty-plus years. I would have never imagined that I would be carving wood since 1985 as a vocation.

In high school and college, many of my art instructors praised me for my efforts but always suggested that my level of talent wasn't up to par with many of my fellow art majors. Each time, the message stung, but it also served as motivation to improve. Upon graduating college, my first job was teaching high school students art. Many of the students weren't interested and couldn't see any practical application for art. I noticed many of the boys had pliers and pocketknives on their belts. It was the late 1970s, and this was ranch country. To attempt to capture their interest, we did lead casting with scrap materials from the local automotive garage. We also picked up scraps of wood and end pieces from the lumberyard. I learned to carve wood right along with the kids.

A few years later, my husband, Bernie, and I had our first and only child, and I left my teaching career to stay at home more with our son. Wanting to help supplement his teaching income, we set the objective to have my art business earn $100 per month. At the time, I was doing T-shirt designs, greeting card designs, and even coaching junior high volleyball. There were months when that $100 goal wasn't met.

But I continued to carve, and one day I saw an advertisement in the newspaper for a carving show in nearby Omaha, NE. We attended, and my work was viewed favorably. I still remember selling three pieces at that show, one of a raccoon and two others that were Christmas ornaments, for a grand total of $106. We still wonder how we came to price those carvings—the raccoon was sold for $92 dollars and the ornaments for $7 each. I'm quite sure that the time we spent traveling, the show fee, and the other incidentals weren't covered by what we earned at the show. But it did give me confidence.

This show gave us connections to other shows in Wichita, KS, and Kansas City, MO, and from there things just kind of mushroomed. One of the most important lessons I learned during this time was the value of show participation and viewing each show with equal importance. Many times I've heard a show referred to as a "big show" or "small show" or "important show." But we always believed they were all of equal importance. We were putting our work out for new people to see in different locales, and we understood that to the carving group that was hosting the show, this was their most important show of the year.

After winning some awards and selling my work at the Wichita and Kansas City shows, I set some new goals with my husband: to be recognized nationally in the medium within three years, and to be internationally recognized within five years. I enlisted my husband's assistance in doing some of the woodburning, sanding, and finishing bases, as well as handling the business side of carving.

In 1989, my husband took a year's leave of absence from teaching to work with me full time and see if we could make a living if both of us were carving full time. Things went well, and although he continued to teach until 1995, we knew we had found a lifestyle.

Over the years, we have taken a lot of chances through the business. Some have worked; many haven't. I remember being recruited to attend a log cabin show in California. The person selling spaces was a good salesperson. When I said, "People aren't going to a log cabin show to buy artwork," her response was, "While the husband is cutting the deal on the home, the wife is looking for furnishings. And your wood will fit the décor." I hate to admit that in this case, my being right cost me a lot of money: people didn't come to buy my artwork. At another time, we received a letter from a company in California wanting to reproduce my pieces and sell resin castings at gift shops throughout North America. The only reason we responded was because their telephone number, listed at the bottom of the letter, was an 800 number. It turned out to be a very successful venture: they sold over 93,000 of the reproductions. I imagine we've had far more failures in our business than successes. But never once did failure keep us from moving ahead.

Taking these chances came with doing some things that I wasn't comfortable with. I have absolutely no sense of direction, and in the early years of flying to teach seminars and do shows, I was scared to death going through the airports in large cities. We were fortunate that during these earlier years, and while my husband was still an educator, his parents would come up to take care of our young son, and his father would drive me to and from the airports of departure in Nebraska. I was also fortunate that the vast majority of the people that let me stay with them while teaching seminars were wonderful people. Sadly, a great many have passed, but they were some of the finest people we'd met.

My hope is that through all these years, I have been a positive role model as well as an ambassador to spread the word of carving, not only to carvers and carving groups but at the fine art and sculpture shows we've attended as well. I've tried to present what I do as not only a craft but an art form.

It's been a wonderful experience, and I can truly say that all I've learned and shared through carving has been cumulative. I thank each and every one of you for your support through the years and wish you joy and happiness in all your carving experiences. I hope your journey is as wonderful as mine has been.

One final thought. One of the most frequently asked questions I get is, "How long does it take to do a carving?" After much consideration, my answer to that question is obvious: "A lifetime."

Desiree Hajny

Getting Started

This is not a beginner carving, woodburning, or painting book, so it won't teach you the very basics; it assumes you already have some knowledge of basic tools and techniques and a little bit of practice under your belt. That said, in this section, you'll review all the key stages of creating the carvings in this book: researching, choosing the right tools and materials, carving, texturing, woodburning, and, of course, painting.

Researching

As I have become older, it has become more apparent to me that those people that are very successful in whatever they do are excited about what they are doing. Their enthusiasm carries over to their endeavors. I believe that your enthusiasm is vital in attempting to carve a piece that will not only be significant to you but also to the others that are viewing your work.

Your research becomes just as important a factor in the overall process of the piece you are working on as the physical techniques of the carving, texturing, woodburning, painting, and finishing are. A carving that has flaws in its overall presentation because of a lack of research will never be as effective as one that has been thoroughly thought about and in which the nuances and intricacies of the particular subject are brought forth accurately.

This raises the question of artistic license—can't we, as artists, do what we want with our subjects? My personal interpretation of artistic license is that you must know your subject thoroughly and apply this knowledge in order to stretch, simplify, or omit but all the while not lose the essence of your particular subject.

Here are some key factors to consider when choosing a subject:

- Analyze the ideas, experiences, and feelings relevant to the subject that are significant to you.
- Out of these, select the ideas, experiences, and feelings that you believe are the most important.
- Relate these ideas through the use of materials (media) in an orderly arrangement (design) that emphasizes reality in a personal way (style).

The feeling of a carving subject is lost unless it is backed by knowledge about the subject. You must understand and study your subject. I mention in the introduction my frustration in my first teaching experience in a ranching community. There were things that were significant to me that did not interest the students at all. When I introduced carving as a unit of study, it piqued some interest, because most of the boys, and some girls, carried pocketknives to school as part of their attire related to their lives on the ranch. The knives were necessary for the work they were used to doing. This interest was furthered when the students were given the choice of what to carve. I learned more about rodeos, cowboys, steers, bulls, and horses than I could ever have imagined during my time at that school. These weren't subjects that I was particularly interested in, but the students were.

If you are particularly interested in something, like the sport of rodeo, for example, channel that interest into your carvings instead of forcing yourself to just carve calm, grazing horses. Your work will be stronger and you will be happier.

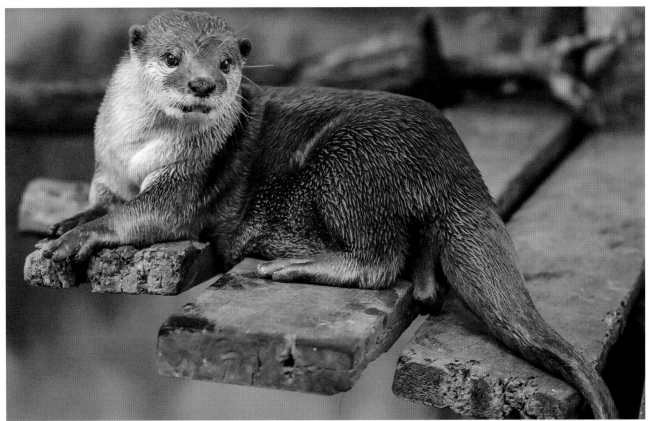

Zoos are a perfect place to study your subjects in real life. The Internet, of course, has many videos and photos, but there is nothing like watching the living, breathing animal just feet away from you.

Applying yourself to things you are interested in will help you reach your potential. If you're not interested in something, look for something else. This message especially hit home with me years back, when a veterinary office commissioned me to do a carving of each breed of dog on the chart in their office. There was no room for changing the pose of each dog, and soon I became uninterested and couldn't continue. I'd always been a dog person, but I simply wasn't that interested in carving many of the breeds on the chart, and the lack of flexibility was stifling.

I can't stress enough the importance of being excited about your project. Once you have decided what it is you want to do, gather as much information as possible. Today, many online resources are available. I admit, when it comes to modern technology, I am a bit of a dinosaur, but if I have a deep interest in a project, I may need further information that resource books alone can't provide.

Sometimes, though, my research is more hands-on. I love to go to zoos to watch my subjects move. I try to focus on different parts of the animal in question and think of how I will incorporate these different aspects into my finished product. How the hip tilts…backbone and lumbar movements…how one body part moves while another is moving… The study of shapes and curves is important to ensure the flow of a design, whether it is a stylized, realistic, or cartoon-like design. If you are interested in carving people, go to public events and people watch. In circumstances such

as a sporting event, you will see a wide variety of looks and emotional responses.

Taxidermy mounts are good reference, but keep in mind that a particular mount may not always be accurate when compared to a live animal. Sometimes the skins mounted are old and cracking. Sometimes the taxidermist may not have done his or her homework. But there is usually consistency in the nose pads, claws, dewclaws, hooves, antlers, and ears.

In the past, while carving canines, I would put our dog to work. I'd observe her, and if I had a question about how one part of her body moved in conjunction with another, I'd try to pose her in that particular position. I got some strange glances from her over this, but it is an interesting and realistic manner of checking into a particular question I may have.

Don't be afraid to search deeper into your subject. You might touch upon a certain element that makes your mouth water or that gives you goosebumps. Years ago, I was working on a carving that held special interest to me. It was a wolf mother and her pups, and it was a gift for my mother; the pups represented myself and each of my brothers. I enjoyed the process, and it became much more meaningful to me because I was able to give features to each of

Taxidermy mounts can be good reference for things like antlers, claws, and nose pads, but are sometimes less reliable for skin and other aspects.

Try using modeling clay instead of paper and pencil to create a "sketch" of your carving.

the pups that reminded me of each family member. Naturally, there was a great difference of opinion among my brothers as to which puppy represented each child in the family—not to mention what my mother thought!

Once you are firmly inspired and have sought out your references and research, sketch ideas. These sketches will aid in the process of visualizing and planning your carving. In planning a successful carving, you must have a basic structural understanding of the forms to be used in order to create the finished product. These sketches can be considered a rehearsal for the carving process. Creating ideas and redrawing and refining them will help you get to the carving stage with confidence. Sometimes you'll make several sketches and then combine them together into one idea.

For those of you that feel you can't draw, try using clay for your "sketching." You can twist and turn the clay until you get what you want. Not everyone possesses the ability to visualize three-dimensional works from a two-dimensional rendition. The clay will work well for those with skills in the tactile-kinesthetic area.

Ideas feed off of other ideas. Bounce ideas off others and get reactions from a spouse, parent, best friend, or someone else who will be honest with you. If you can learn to get past the initial shock of a possible critique, you can often gain valuable input.

The key takeaway here when it comes to research is to undertake a subject that is of interest to you and that will hold your interest for the duration of the project.

Carving

As we saw in the Researching section previously, I believe you should carve what you're passionate about. For me, that has been wildlife. I've dabbled in some other subjects, but I always return to what motivates and excites me about carving, and that's wildlife. If you've picked up this book, I suspect you feel the same way as I do, to a certain degree.

But I also believe it's important to try other things, just to see where your areas of interest lie, and also to develop diverse skills and techniques within your repertoire. For example, I did caricature carving for a while, and I have applied what I've learned through caricature carving to the carvings I produce now. I often slightly exaggerate each animal in some way. It may be in the face, a particular area of the body, or the feet. If I'm doing a baby cougar, maybe I will slightly exaggerate the size of its feet. I have also been inspired by the beautifully carved and woodburned features of many bird carvings I have seen at shows; once I asked what burning tool had been used to create these masterpieces, then went out and bought one myself (it was a Detail Master). Though I'm not as interested in bird carving or caricature carving, I have applied their principles to my own carving career.

I can't recommend an exact list of **tools** you'll need to achieve what you desire in your carvings. When someone asks me whether I use hand or power tools, my answer is "yes." I use them both, and whatever works to get wood out of the way, I implement. Some of the seminars I have instructed

Basswood is a classic choice, and it's one of my favorites.

It's imperative that you use a carving glove, no matter how small or quick or easy you think the cut will be.

over the years have been on power carving and some have been strictly on hand tools. It has been important for me to be able to adapt and use both. When instructing a class and moving from student to student, I demonstrate different techniques using whatever tools the student may have on hand. I've had several discussions with "purists" who have told me that it's cheating to use power tools—but I have a theory that if Michelangelo had had access to power tools, even he would have utilized them on his masterpieces. For this reason, I won't prescribe you a specific set of tools to use while carving, but I will give some suggestions and options (see page 29).

When it comes to **wood choice,** I tend to enjoy basswood and butternut the most. I have nothing against tupelo, but the wood doesn't lend itself well to hand carving. You should experiment with several different kinds of wood and see which kinds give you joy to work with; some people enjoy the softer, forgiving woods, while others prefer harder woods with more personality. Each of the pieces in this book was carved in basswood, which has a consistent grain and is fairly soft.

The one thing I would strongly recommend for hand carving is to make sure that you wear a **carving glove**. I've gotten some of my worst cuts when I've been in a hurry, just wanted to cut a very small area, and didn't put on my glove. Several years back, I went to my shop to make a small cut on a carving. I forgot to put on the glove and cut a tendon severely on my index finger. The orthopedist said I would be lucky to get seventy-five percent effective usage out of it again. After several years of rehabbing it, I think I may be up to about eighty-five percent. Learn from my mistake. It's always better to be safe than sorry.

When I first started carving, I carved each animal separately and mounted each one to a **base**. I found out that in carvings, much like in furniture, the wood would shrink and swell. Competing in my earlier years in larger shows, I would ask the judges what I needed to do to improve. The answer was usually the same: "Carve it as one piece." I have done this for some time now, and I definitely see the advantages. Though the process is more challenging, when it came to competing, most times it gave me an advantage over pieces that weren't all one piece. I've judged competitions in seventeen states as well as in Canada, and when I'm making a final decision, a work that is all one piece of wood versus one that is not will ultimately get the nod because of the difficulty in execution.

The same can be said about creating your own **style**. In the early stages of your carving progress, when you are learning the proper techniques, copying something may be a good way to develop confidence in the use of your tools and help get you to the next level. But you can't keep copying forever. As a competition judge, when I see entries that copy popular photos or another carver's work, I invariably assign those pieces a lower grade than I do for an original design. This isn't something that's exclusive to carving, either. I've done a number of wildlife art and sculpture shows through the years and have seen ideas presented that weren't original in all mediums ranging from flatwork to bronze. You should develop the fundamental skills of carving first, by copying if necessary, and then use these skills to blaze your own trail, so the style you've chosen will be recognizable to the viewing public as yours and yours alone.

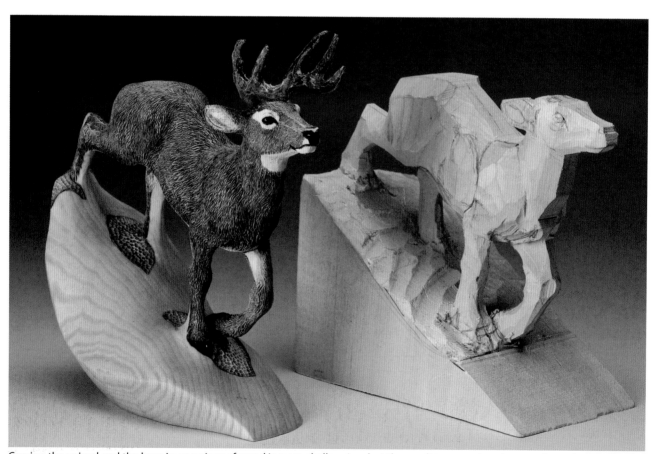

Carving the animal and the base in one piece of wood is more challenging, but the result is more stunning, sturdy, and streamlined.

Texturing

Texture is defined as the characteristic visual and tactile quality of a work of art resulting from the way in which the materials are used. In other words, it's how the light and shadows play on the surface.

To begin the texturing process, the artist must first study fur layout. Is the fur long, like the fur on a winter wolf, or short, like on a river otter? Does it have the shaggy qualities of a donkey, or is it wiry like a raccoon?

One of the frequently asked questions I get at a show is, "How do you get the texture?" My answer is always the same: "Which one?" There can be different textures on an individual animal. The rabbit has flat textures on its ears, but also a fluffy, soft dewlap (chest area). It also has soft, layered back fur and short hairs on its feet. After figuring out the textures, the artist must then decide which techniques to use to create those textures.

Following are some tips for texturing, and the accompanying charts will illustrate the different tools you can use. Both hand tools and rotary tools are effective for the texturing process. It will depend on your preference of which to use, or, as in my case, you can use a combination of both.

The texturing on this elephant is very visible.

Texturing Tips for Hand Tools

Gouges (#5–#7)

These gouges not only can be used to remove large chunks of wood, but also can be used to create softer, furred areas on animals such as cats, rabbits, chipmunks, and otters. Repeat your strokes and keeps the cuts close together. Experiment with different sizes; my favorite for these projects is #6, but you might prefer a different size.

The rotary bits that are comparable to these gouges are the egg, round nose, and ball.

Veiner (#11)

This particular tool can be used for texturing larger furred animals, such as wolves, foxes, and many of the wild cats. It gives a softer separation of the locks of fur, belly hairs, and thick neck hair.

The rotary bits that are comparable to this veiner are the pear, taper, and bud.

V-tools (⅛" [3mm] 60°)

V-tools can create a longer illusion of fur just by lengthening and concentrating your strokes. V-tools can be used to create natural-looking fur texture on areas such as a grizzly bear torso, the roached mane on a zebra, or the bristles on a hedgehog. They come in a variety of sizes, but the one I used for these projects and recommend to you is the ⅛" (3mm) 60° V-tool, by some manufacturers designated #41. Again, you can use other sizes either slightly smaller or larger than this particular size, but this is my favorite.

The rotary bits that are comparable to a V-tool are the taper, bud, inverted disc, cylinder, and disc.

Texturing Tips for Rotary Tools

If you use rotary tools and you seek a shallow, fuzzy texture, like for rabbits, domesticated cats, chipmunks, or otters, the ball, egg, round nose, or pear will work well for these textures.

Comparable hand tools are #5–#7 gouges.

If you want to achieve a sleek, longer fur texture like on wolves, foxes, wild cats, for belly hairs, or for neck hairs, the bits to use are the taper, round nose, pear, and soft disc.

A comparable hand tool would be a #11 veiner or a V-tool.

For sharper, deeper cuts that would give the illusion of a grizzly bear, donkey, or hedgehog, the bits to use are an inverted disc, disc, taper, bud, and cylinder.

A comparable hand tool would be a #11 veiner.

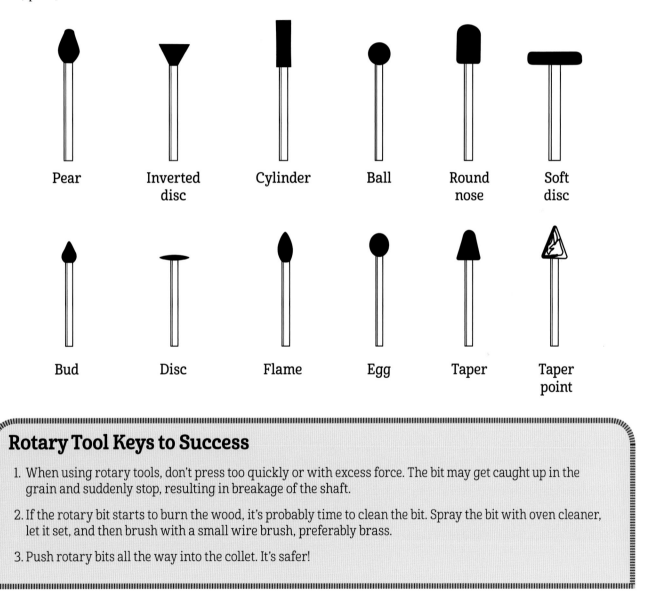

| Pear | Inverted disc | Cylinder | Ball | Round nose | Soft disc |

| Bud | Disc | Flame | Egg | Taper | Taper point |

Rotary Tool Keys to Success

1. When using rotary tools, don't press too quickly or with excess force. The bit may get caught up in the grain and suddenly stop, resulting in breakage of the shaft.

2. If the rotary bit starts to burn the wood, it's probably time to clean the bit. Spray the bit with oven cleaner, let it set, and then brush with a small wire brush, preferably brass.

3. Push rotary bits all the way into the collet. It's safer!

Woodburning

Tips and Their Uses

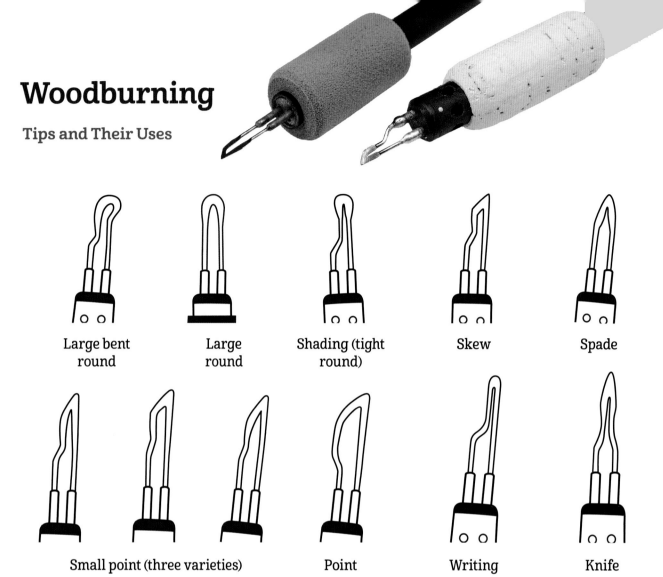

Large bent round **Large round** **Shading (tight round)** **Skew** **Spade**

Small point (three varieties) **Point** **Writing** **Knife**

Woodburning Keys to Success

1. For enhancement of textured lines, run a longer stroke down the textured line. It's more natural looking and gives continuity and fluidity to fur. Use random-length strokes and overlap and undulate lines.

2. Select the tip shape that works best for your chosen texture strokes.

3. If you feel friction and have to force the pen to get depth, then your pen is too cold.

4. If the pen point goes in too quickly and has yellow on either side of the cut, then the pen is too hot.

5. Clean up the textured area with a defuzzing pad or brass brush. This will take off the wood fiber that will show up after painting. This will also take off charcoaled areas left by a hot burner tip.

Woodburning seems to be something that people either like to do or hate to do. If it's not for you, don't burn. I've seen a lot of pieces that were wonderfully carved, textured, and then ruined with poor burning. It's tedious work, but when done correctly, it adds to the piece.

If you do choose to burn your pieces, try not to burn at a very high temperature. If you burn at a high temperature, the process may be easier and faster, but when you come to the point when you paint the piece, dark burns tends to absorb the paint much more than lighter burns, and you may have to apply several layers of the paint to cover up the dark areas.

I personally use several different woodburning tips to accomplish the effects that I desire. Here is a quick tour through some of the main tips I use and how I use them. Try to achieve what I do with the same tips, or experiment with the tips you have on hand. There are a lot of tips out there to try.

The **shading (tight round) tip** can be used in the heavier textured areas. Separate strands of hair are created with the shading tip. Cross over each high area between the textured cuts to redefine these areas. Remember to follow the flow of each hair tract illustrated for each animal. To layer fur,

especially on a section that is an overlay, a curl, or separation, do not bring the strokes all the way to the edge of the top layer. Leave a little space, and come into the lighter upper area from the lower shaded area with a few well-curved strokes.

The **writing tip** can contour the nose textures by dotting over the nose pad of different animals with dark nose pads. Examples would be raccoons, pandas, fawns, foxes, otters, and wolves. It can also be used to hollow out ears on the rabbit, raccoon, chipmunk, kangaroo, panda, fox, bobcat, fawn, donkey, and otter. Use the writing tip to add whisker dots on the raccoon, chipmunk, rabbit, otter, wolf, fox, and bobcat. You can also use the writing tip to burn spots on the bobcat and fawn or stripes on other animals. Finally, use the writing tip to squiggle skin like the texture on an elephant. The writing tip is also a good tool to use for wrinkles.

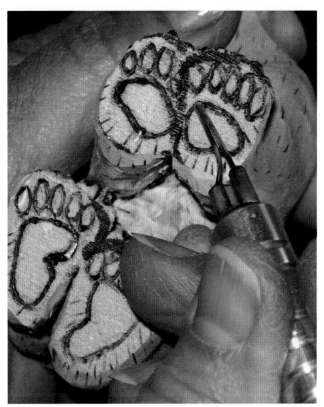
Use a writing tip to burn things like the thick outlines of foot pads.

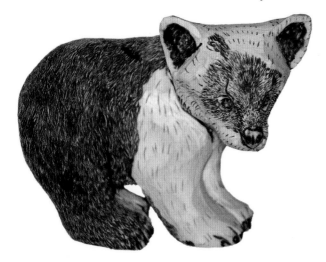
Use a stab-and-pull motion with the skew tip to first mark the general direction of fur, then to fill in all of the fur texture. You can also use the shading tip to create fur.

The **skew tip** is used to outline the eyes, mouth, and clefts on each animal. Use very short strokes for tiny hairs, such as on the face. Hold the tip at the same angle as a pencil, pushing the point down and pulling up. You can use the skew tip to burnish the donkey and fawn hooves by pulling it sideways across the surface of the hooves. I use the skew tip on a good portion of the animal body fur as well.

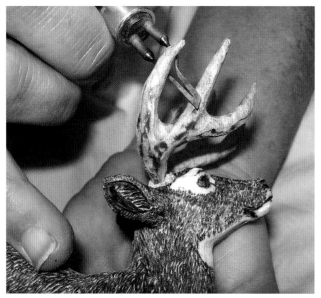

You can burnish hooves, antlers, and other features with the side of the skew tip.

Those are the three main tips I use for a large portion of my work. But there are many other tips with a variety of uses. Here are some more general tips, plus tricks for using them. Burning tips that are rounded and flat on the end are called shaders (shading tips). These tips can be used to **break down textures** to enhance their realistic appearance. They include the large round, large bent round, and tight round. If you are searching for more points that lend themselves to **detail work**, these tips work well: spade, small point, point, and knife. These are best for tiny hairs on the nose, eyes, cleft, and mouth. They can be pulled sideways for burnishing hooves, horns, or antlers.

Common Mistakes and How to Fix Them

 Burner held to the side during hair marking.

To correct, move the tip more perpendicular to the wood surface.

 Burned marks too parallel.

To correct, fill in areas that are bare wood with other marks at different angles.

 Burned marks leave too-large areas of unburned wood.

To correct, use tip to fill in areas.

 Too much space between individual marks.

To correct, slow down—you're in too much of a hurry to fill space.

 Too-bold or too-obvious change in hair direction.

To correct, change direction subtly along backbones, on center points along the nose, and between the eyes.

 Details (such as eyes, claws, nose pads) burned but not outlined.

To correct, turn the tip around so that you have more of a pencil-like tool.

 Crossed pupils.

To correct, mark pupils with a pencil first to make sure they are aligned.

Painting

A good paint job can make a good carving great. Conversely, a bad paint job can make a good carving bad. Use your painting to enhance your carving, to give it light and shadow, and to add depth to the piece. Before you put paint to wood, be sure to study the colors of the chosen animal and be aware of what time of year it is in your carving, especially if you plan to include background/landscape texture. Most animals are lighter in winter so that they blend in with the snowy landscape; animals' summer colors tend to be richer to blend in with the summer foliage.

There are many styles of painting. Wildlife artists use a variety of methods, including watercolor, oils, acrylics, colored pencils, markers, and stains. I most often use **acrylic** paints, and that is the paint used for each of the animals in this book, so I will focus on acrylic methods here. You may also want to experiment with other painting methods and techniques to achieve different outcomes. Remember, there is no wrong or right way to paint—use whatever method serves you best.

I usually paint the piece in the following order: head, neck, shoulders, front legs, body, back legs, and tail. Because acrylics dry quickly, I find that **mixing the color** for each part of the body just before I want to paint that area works best. Mixing acrylics is easy. First put the color on your palette. Then fill your brush with water and touch the brush to the paint. Mix the paint and water to a milky consistency and apply it in washes, like a stain. When I get ready to start this process, I use a soft round brush.

Make sure to always keep the paint somewhat **thinned**, regardless of which paint you use. Paint that is too thick will clog the texturing you worked

This bobcat's fur has many patterns and shades.

hard to achieve. Paint that is too thin, though, won't provide proper coverage. When you thin the paint, it will also allow the colors to blend together more naturally. Start by applying the lighter colors, then gradually work in the darker colors (this also holds true for watercolors). If you are using oil-based paint, start with the darker colors first. Remember, the darker the burned area, the more paint you'll need to be able to see the color and achieve your desired result.

Know where your **light source** is coming from, and keep it in mind at all times. What areas of your carving will be in shadow and what areas will be hit by the light? You'll want to darken the shadowed areas with a small amount of black paint added to the base color. Lighter areas can be brightened by adding a small amount of white paint.

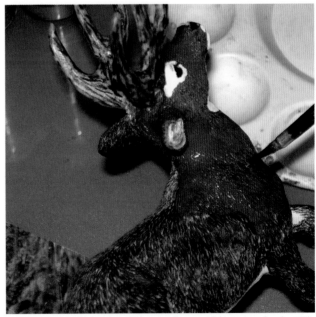

Start with thinned colors. You can always add more color, but it's difficult, if not impossible, to remove color once applied.

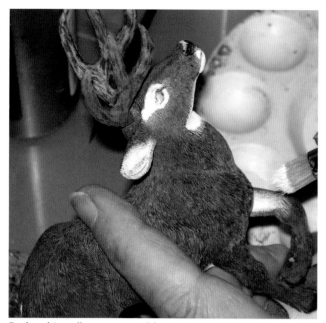
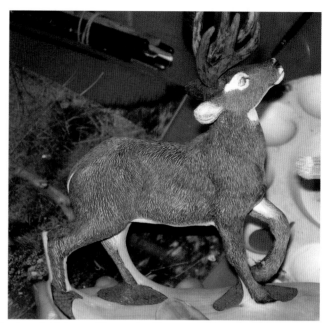

Drybrushing allows you to add a natural color variety to an otherwise too-vivid, too-uniform color. You can see here how drybrushing the deep brown deer with a mix of golden brown and white turns it into a much more natural shade.

I follow a general **three-stage process** when painting my pieces, which I will recommend to you throughout this book. First, apply the colors quickly, allowing one color to bleed into the next. This technique is called **wet-on-wet**. Be sure to let all the wet-on-wet completely dry before you start the next stage, which is drybrushing. For the **drybrushing** portion, use a stiff-bristled brush. Drybrushing will show off the texture you have created through carving and woodburning. To drybrush, scrub a small amount of a color into the brush, pat the bristles against a paper towel to remove any excess, and pull the brush gently in the opposite direction of the hair. The last stage of painting is the **detailing**. Use a detail brush to add details like eyes, hooves, claws, and nose pads.

When the animal is completely colored the way you wish, use the **leftover colors** on the base of your piece so the colors on the animal and its habitat blend together. Mammals are generally colored to blend in with their habitats. By using your leftover colors in this manner, you can be sure the colors in your animal match the colors in the

habitat perfectly. Plus, you haven't wasted paint. The projects in this book are freestanding, but this tip will allow you to improve your other works while painting, and hopefully you will be encouraged to carve or create interesting bases for your animals.

When you're totally happy with the colors, the piece is ready for **finishing**. Use whatever finish you choose. I have used a low-gloss Tung oil for the pieces in this book and have applied a two-part epoxy to the eyes. Remember to epoxy the eyes after doing the finish work. If you don't, the finish will dull the eyes.

Common Paint Techniques to Try

You don't have to feel limited to the exact instructions I give for painting throughout this section and for each animal. Try any of the below techniques yourself on your projects. Most of these techniques, except the last one, apply to acrylic paints.

Wet-on-wet: Use this process to blend two colors. Apply the first color to your carving, then subtly blend in the second color while the first is still wet.

Use a detail brush to paint small, delicate areas like eyes and the white eye highlights.

Drybrushing: Use this technique to give just a hint of color to your painted piece. Use a stiff-bristled brush and apply a small amount of paint lightly to a dry area. This works well for areas with lighter colors. Use this also to set off areas the light hits on the carving.

Scumbling: Use a circular scrubbing method with your brush to apply paint to the wood. Be careful when scumbling not to ruin subtle texturing.

Glazing: Mix polymer medium with acrylic paint and apply to the carving. This works well for creating light colors with a shiny surface and smooth texture.

Lifting: Apply paint and then use a wadded-up piece of tissue or a sponge to remove some of the paint. This works great for adding texture to a habitat.

Salting watercolors: Sprinkle salt on wet watercolors. When the paint is dry, brush away the salt for a glistening appearance. This works well for snowy scenes.

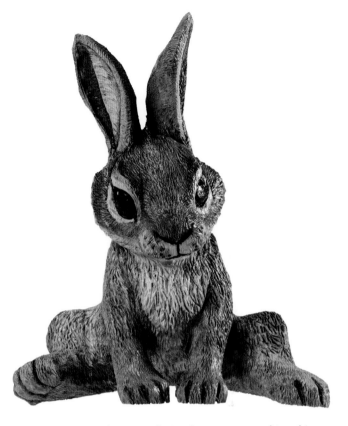
An epoxy finish on the eyes will give them an eye-catching shine.

Salted watercolors are perfect for a snowy texture.

Tools and Materials

The following is a suggested list of materials for the projects in this book; they are what I used to create each animal. Please don't feel that these are the only tools you can use for each project. If you have particular tools that you are more comfortable with, use those.

The Wood Blank

If you choose to do your carvings from a cutout, use the pattern provided for band sawing. The piece is 3½" high x 3½" long (across the front) x 2¼" wide/deep (8.9 x 8.9 x 5.7cm). Add extra height for the rabbit as shown. If you would like to order the pre-roughed-out carving blank, see page 151 for ordering information.

Band Saw Cutout - 3½" H x 3½" L x 2¼" W (8.9 x 8.9 x 5.7cm)

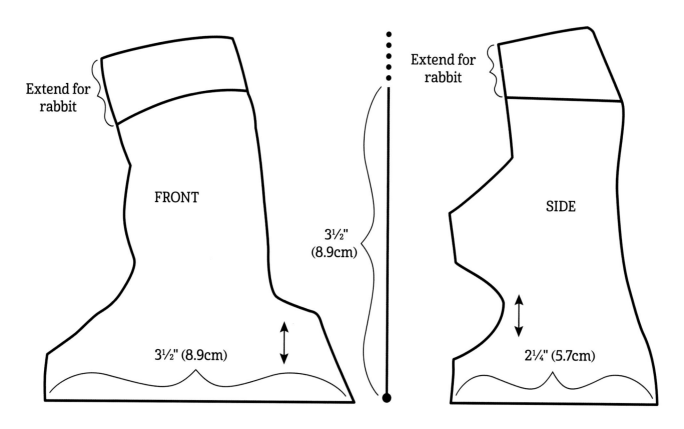

Extend for rabbit

FRONT

3½" (8.9cm)

3½" (8.9cm)

Extend for rabbit

SIDE

2¼" (5.7cm)

Carving

Each letter (A, B, and C) is exchangeable for the corresponding letter between the hand tools category and rotary tools category, e.g., you can use a round nose–shaped rotary bit instead of a #11 veiner, or vice versa (letter C).

Hand tools
- **A:** Gouges: #5, #6, or #7
- **B:** V-tools: ⅛" (3mm) 60°
- **C:** Veiner: #11
- Protective carving glove
- Your favorite carving knife

Rotary bits
- **A:** Round nose or ball
- **B:** Cylinder or disc
- **C:** Round nose

Burning

You will need a variable-temperature woodburning unit (one that you can manually adjust) and the following pen tips:
- Writing tip
- Shading tip
- Skew tip

Writing Shading Skew

Painting

I use acrylic paints. Colors are listed with each individual project. You'll need a few different brushes, as listed below.
- Soft round brush: #8
- Detail or liner brush: #1
- Stiff round brush (for drybrushing): #8

If you decide not to woodburn before painting, apply a wood conditioner, such as Minwax Pre-Stain wood conditioner or a similar product. Allow to dry.

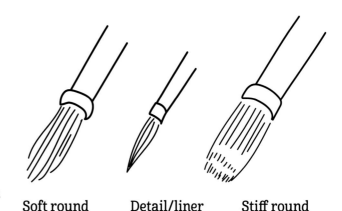

Soft round Detail/liner Stiff round

Projects

Each of the projects in this book is an exploration of an animal personality. For each project, you'll not only get instructions on texturing, woodburning, and painting the animal, but you'll also get a quick view into the habits, lifestyle, and personality of the animal. I hope this inspires you to learn more about each of the subjects you carve—which is important, as you saw in the Researching section! The first project, the wolf, will take you step by step through the carving, texturing, burning, and painting process, and each animal includes full patterns, hair tract info, color guides, and reference photos so that you have all the info you'll need to confidently create it.

Wolf (Step-by-Step)

The wolf is a family-oriented canine—it is quite loving with its family members and very protective. An organized system within each pack allows the pack to survive. Wolves can be many colors, ranging from white to black. They are a beloved symbol of the wilderness.

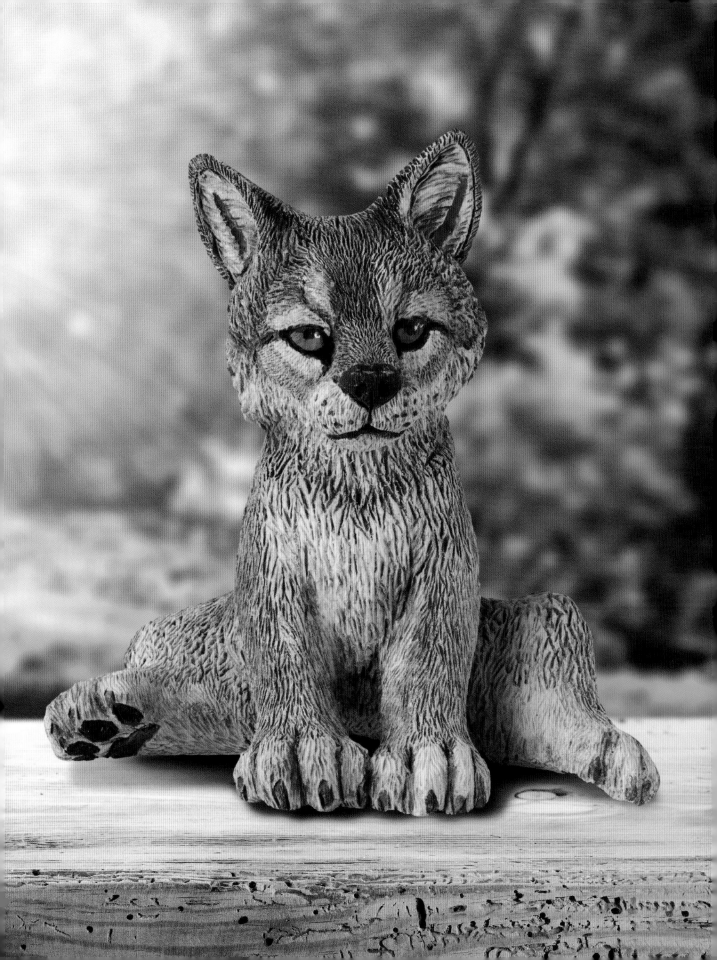

Only two species of wolves exist: gray wolves and red wolves. The pups are usually born between March and April. In the pack, the only two wolves that produce young are the alpha male and female. The litters number from four to six, although they can number as many as thirteen. There is a high mortality rate among the pups due to disease and predation. Though pups are born with gray eyes, their eyes will turn yellow at about eight months. Pups grow rapidly, gaining around 3 pounds (1.4kg) per week for the first fourteen weeks. At around eight to ten weeks after birth, the pups will leave the den for the first time.

Wolves have a much stronger ability to smell than humans and even many domestic breeds of dog. They can smell other animals as far as 1 mile (1.6km) away. For protection against rain or snow, wolves have three capes of fur on their backs. Water runs off these capes in much the same manner as a raincoat repels rain. Wolves' winter coats are thicker and sometimes paler than their summer coats.

Carving

- Tools: carving tools of choice (see page 29)

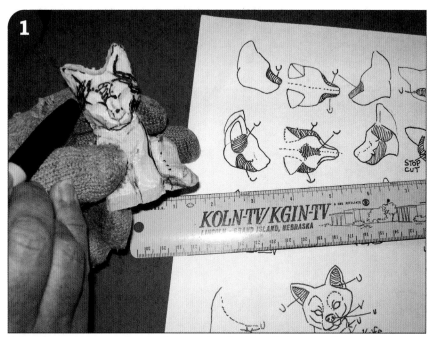

Using the patterns as reference (pages 39 and 40), mark the areas that need to be removed. I usually start with the face. But choose the approach that's most comfortable for you.

Remove these areas with a #6 gouge. You can use a #5 or #7 gouge if you prefer.

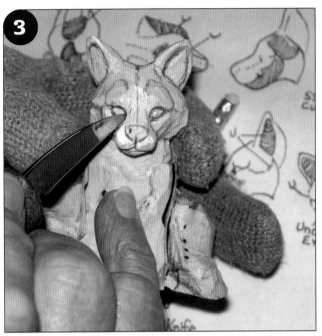

Following the pattern, mark the detail areas that need to be removed on the face. Remove these areas with a detail knife.

Continue to mark and remove areas on the legs and feet using a detail knife.

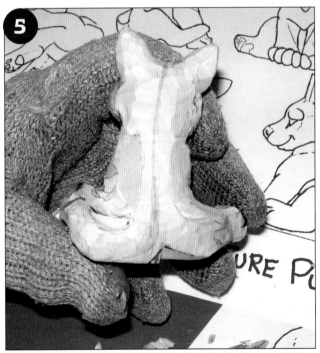

Using your favorite knife, follow the pattern to remove wood around the wolf's body.

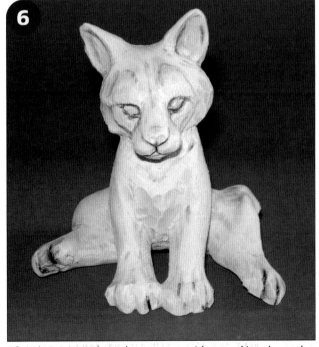

After the piece is shaped up, you can either sand it or leave the cut marks showing. I've chosen to sand it.

Texturing

- Tools: carving tools of choice (see page 29)

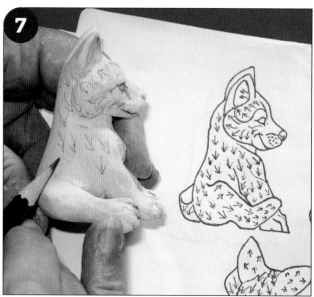

Mark the direction of the hair all over the wolf's body, referring to the hair tract pattern on page 41.

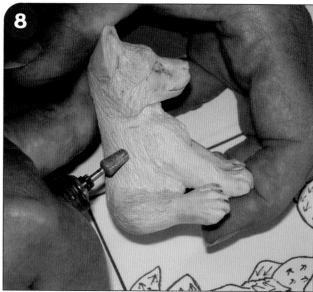

Begin establishing the soft texture of the wolf. If you are using rotary tools, use a ball-shaped bit, using your little finger as a fulcrum for better control. If you are using hand tools, use a #5, #6, or #7 gouge. Apply your chosen tool at a thirty- to forty-five-degree angle. Gently press into the surface, increasing pressure as you push.

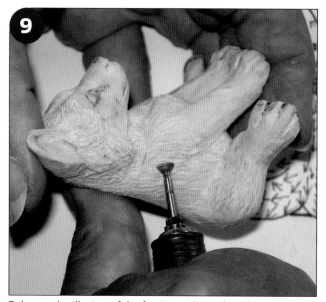

Enhance the illusion of the fur. Use either a disc-shaped bit or a V-tool or veiner of your choice.

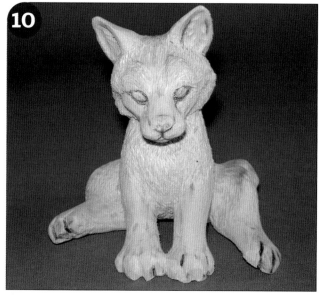

The piece is now fully textured and ready to start the woodburning process.

Woodburning

- Tips: skew tip, writing tip, shading tip

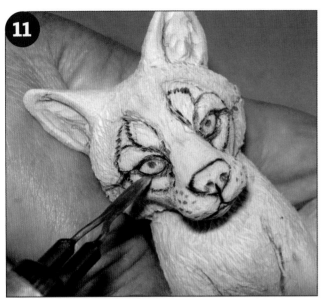

Burn in the eyes, nose, mouth, and details around the eyes with a skew tip. Refer to the pattern on page 42 for reference. For the tiny hairs on the nose, stab and pull at an eighty-degree angle, following the direction of the hair tract pattern.

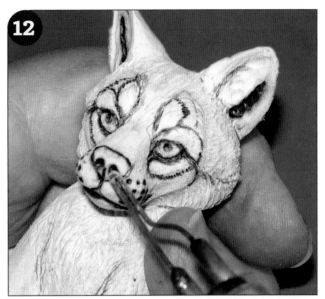

With a writing tip, burn in the nostrils, pupil, whisker dots, and inside of the ears. Use a squiggle motion for the nose pad. For inside the ears, slide the tip back and forth to give the illusion of depth.

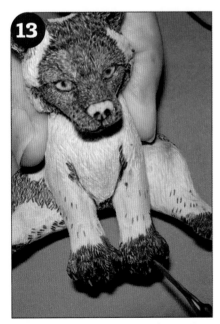

Using a shading tip, burn the fur on the rest of the body.

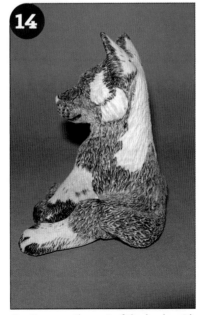

Continue on the rest of the body with the shading tip, following the pattern, until the body is completely burned.

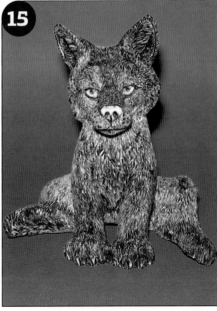

Examine your carving for any messy or incomplete areas, and add the finishing touches as necessary.

Painting

- Brushes: soft round brush, stiff-bristled brush, detail brush, toothpick
- Colors: white, raw sienna, pewter gray, black

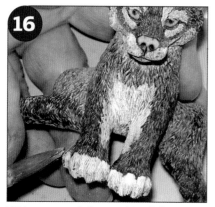

With a watered-down white, follow the painting pattern (page 42) to start painting the body. Use a soft round brush to layer the white areas.

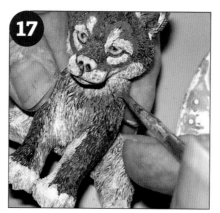

Continue this process with the soft round brush to layer a watered-down raw sienna on the areas shown.

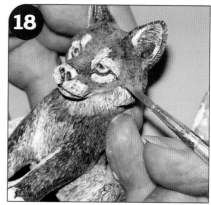

Use a smaller soft round brush to edge all the white and raw sienna areas with a watered-down pewter gray. After edging these areas, use a larger soft round brush to fill the rest of the gray areas.

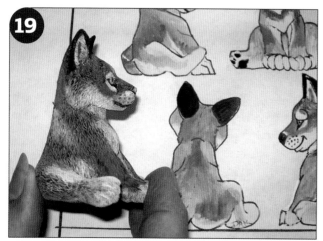

Here's the piece at this point in the painting process. Before continuing to the drybrushing step, allow the piece to completely dry.

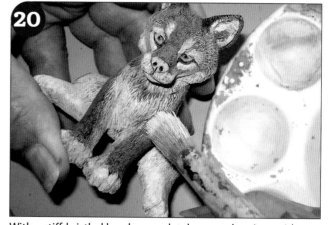

With a stiff-bristled brush, completely cover the piece with white. Lightly dip the brush into the paint, scrub it on a surface such as paper, and gently glide the brush across the opposite direction of the texture. Before continuing to the detailing step, allow the wolf to completely dry.

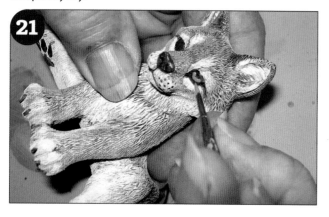

With your favorite detail brush, paint in all the details with black, like the eyes, nose, cleft, mouth, and foot pads. You can either paint in the whisker dots with the detail brush or use a toothpick. Use a toothpick for the pupils and white eye highlights. Finish the piece with your preferred finishing method. I've used a low gloss tung oil as well as a two-part epoxy for the eyes. It's important that the two-part epoxy is the last part of the process—if you apply it before the final finish, the eyes will cloud up.

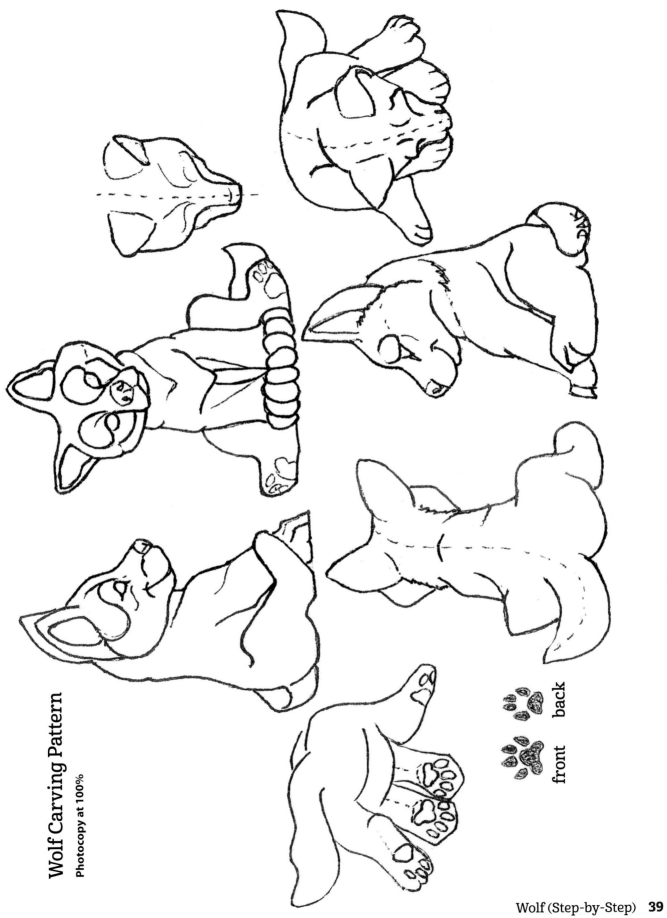

Wolf Carving Pattern
Photocopy at 100%

front back

Wolf Head Shape and Body Details

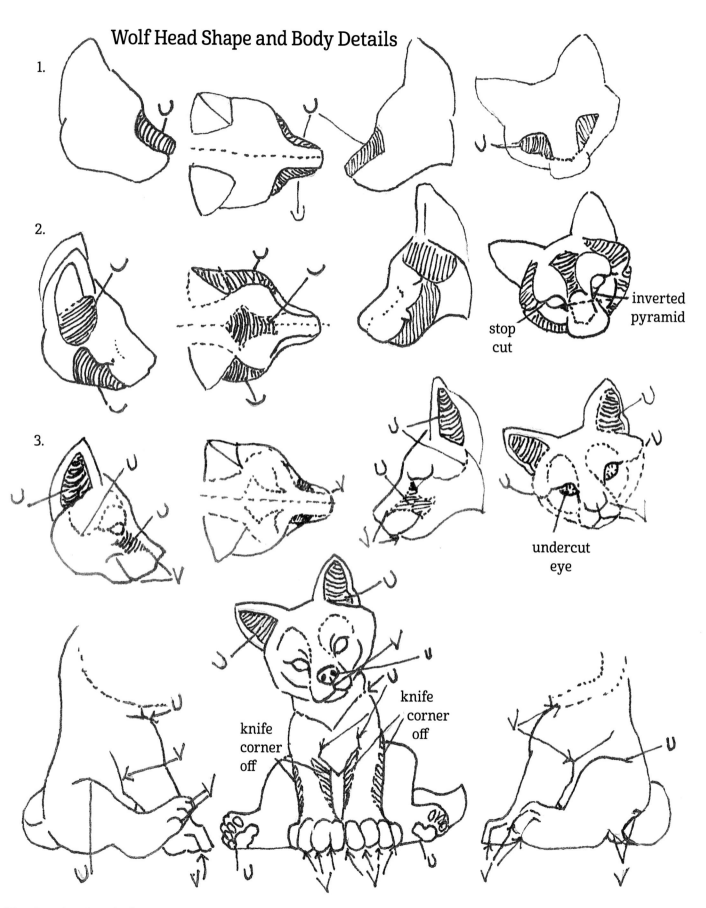

1.

2.

stop cut

inverted pyramid

3.

undercut eye

knife corner off

knife corner off

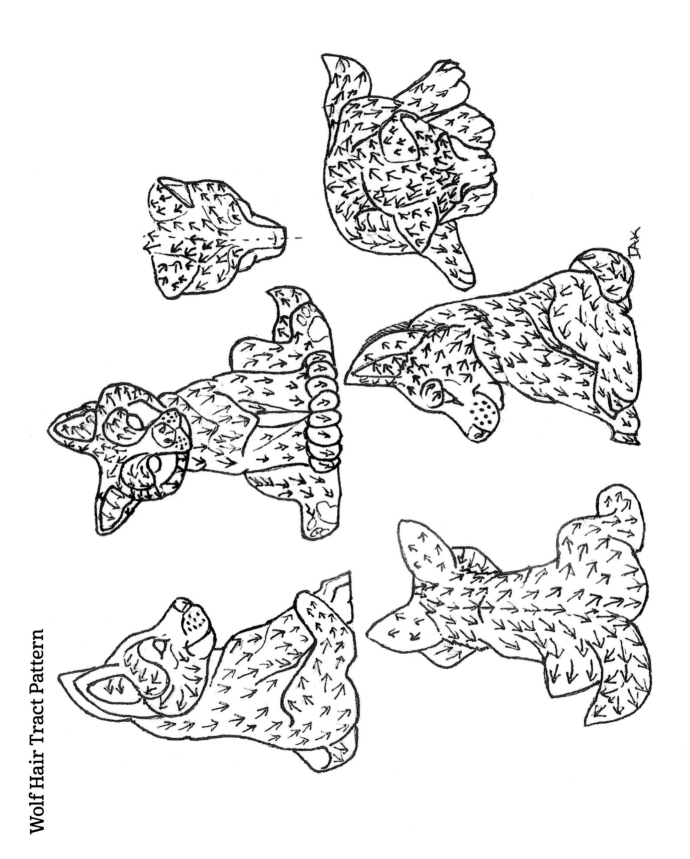

Wolf Hair Tract Pattern

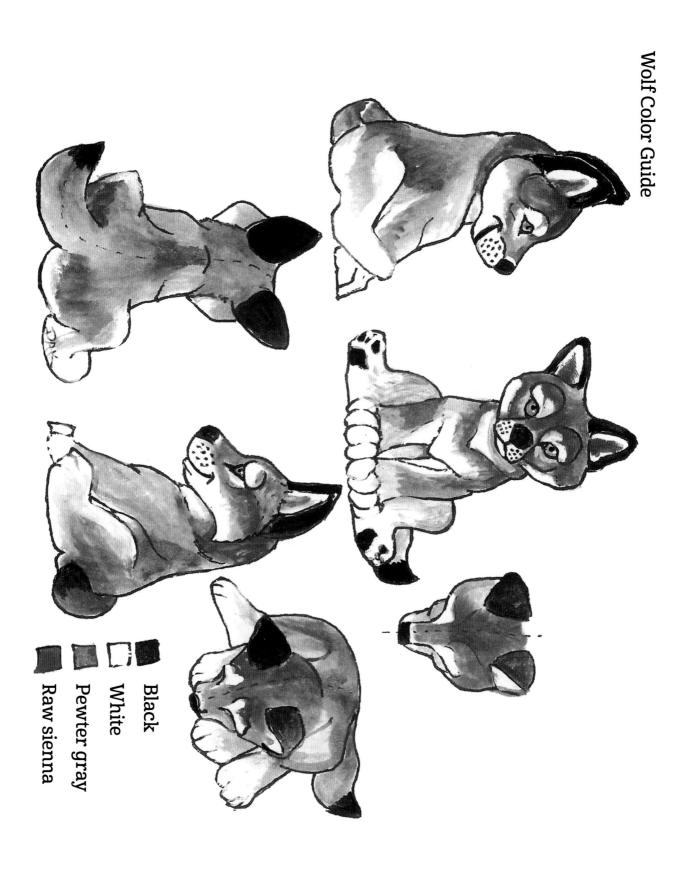

Black
White
Pewter gray
Raw sienna

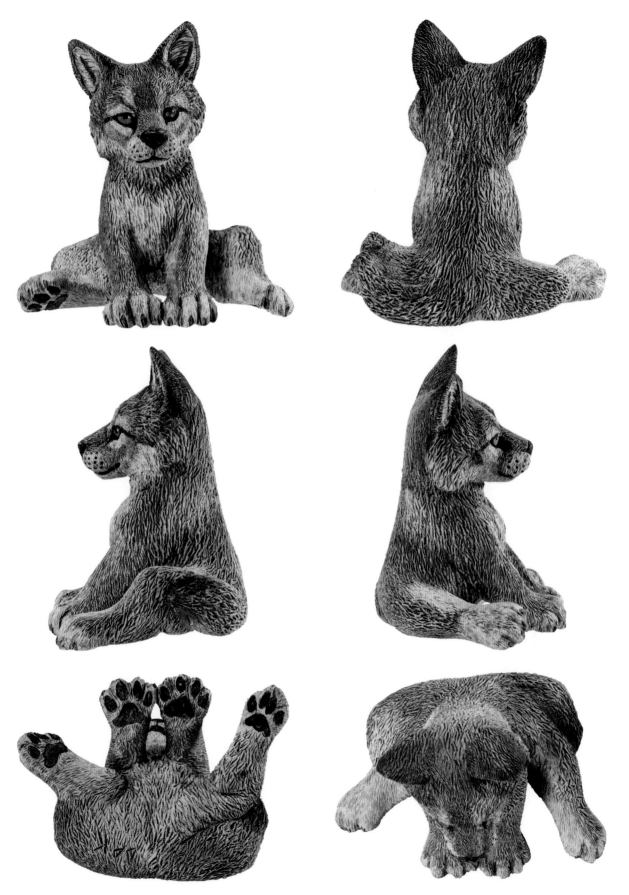

Otter

The river otter has a sleek body with a thick, tapering tail, a long, round head with prominent whiskers and small ears, and short legs with four fully webbed feet. These playful and intelligent creatures have flexible, long, streamlined bodies with dark brown fur. Whenever we visit the zoo, we are always mesmerized by their playful, graceful movements. Otters are fond of sliding down slippery, mud-covered or snow-covered banks near their homes.

River otters, the largest member of the weasel family, are carnivorous. Their diet includes, among other things, fish, crustaceans, amphibians, snakes, birds, water insects, snails, frogs, eggs, and turtles, and they always wash themselves after every meal. They are somewhat social animals, living alone except when the female has young or during the mating period, which is typically late winter to early spring. Litters average two to three pups, although there can be up to six. The pups mature at between two and three years of age. Otter life span in the wild is around ten years, and in captivity it goes up to fifteen years. Made for aquatic life, they can hold their breath underwater for up to eight minutes, and they can dive to depths of 60 feet (18m), but they do spend about two-thirds of their time on land.

Of all the mammals, the otter truly offers endless possibilities for beautiful carvings. The fluid lines of their bodies, reminiscent of an S-curve, is often discussed in sculpture, lending them to a variety of twisting and alluring poses.

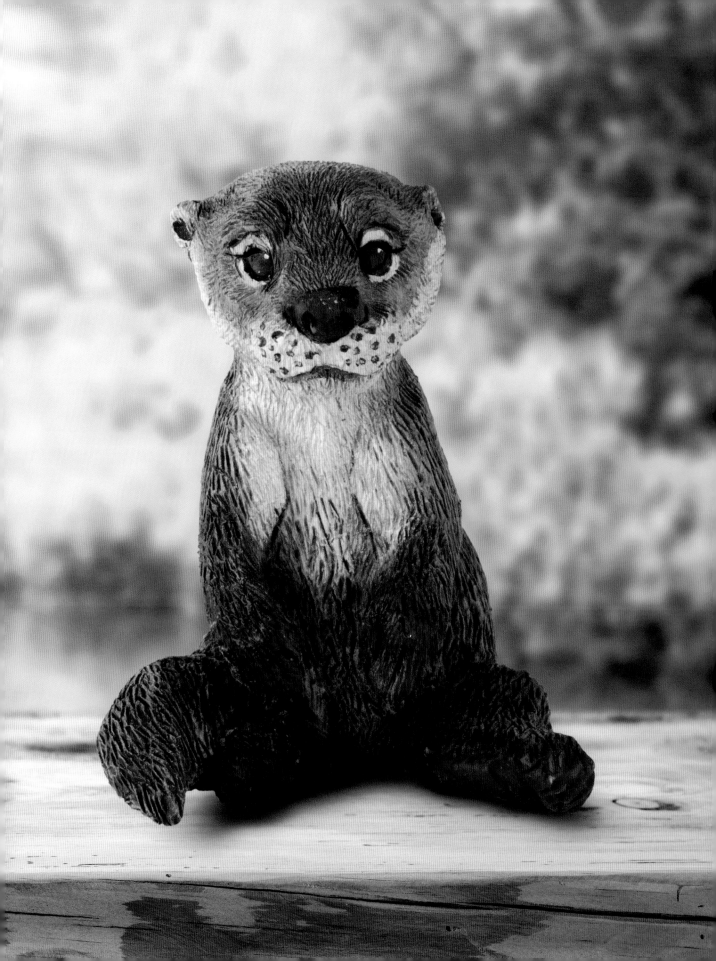

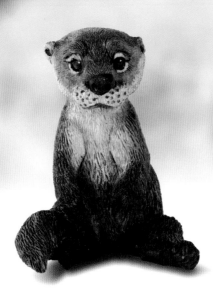

Texturing

- Tools: carving tools of choice (see page 29)

You can either leave the cut marks from the tools you've used or sand the piece smooth. Given the lack of heavy texture on the otter, you don't need to texture it—you can go directly to the woodburning stage to give the illusion of furred areas.

Woodburning

- Tips: skew tip, writing tip, shading tip

Use a skew tip to outline the eye; also burnish the eyeball with the side of it. Outline the mouth and the nose. Holding the skew tip at an eighty- to ninety-degree angle, stab in the hairs on the nose and around the eyes. Use the patterns for reference.

After marking in the nostrils with a writing tip, squiggle the texture on the nose. Dot in the whiskers on the muzzle. Push in the tip for the inside of the ears. Squiggle in the foot pads. Refer to the patterns as needed.

Use a shading tip to burn the remainder of the body in the direction shown on the hair tract pattern.

Painting

- Brushes: soft round brush, stiff-bristled brush, detail brush, toothpick
- Colors: white, burnt umber, raw sienna, black

Following the color guide, prepare watered-down colors on your palette. Using a soft round brush, layer the colors on the otter until you reach the proper shades. Let the piece dry completely before proceeding.

With a stiff-bristled brush, drybrush with raw sienna on the burnt umber areas. Apply white to the lighter areas, the muzzle, around the eyes, and under the chin. For all the drybrushing, do not water down the paint.

Following the color guide and using a detail brush, paint in the eyes and nose with black. For the whisker dots, I recommend using burnt umber applied with a toothpick. Apply a white highlight to the top of each eye with a toothpick.

Otter Carving Pattern

Photocopy at 100%

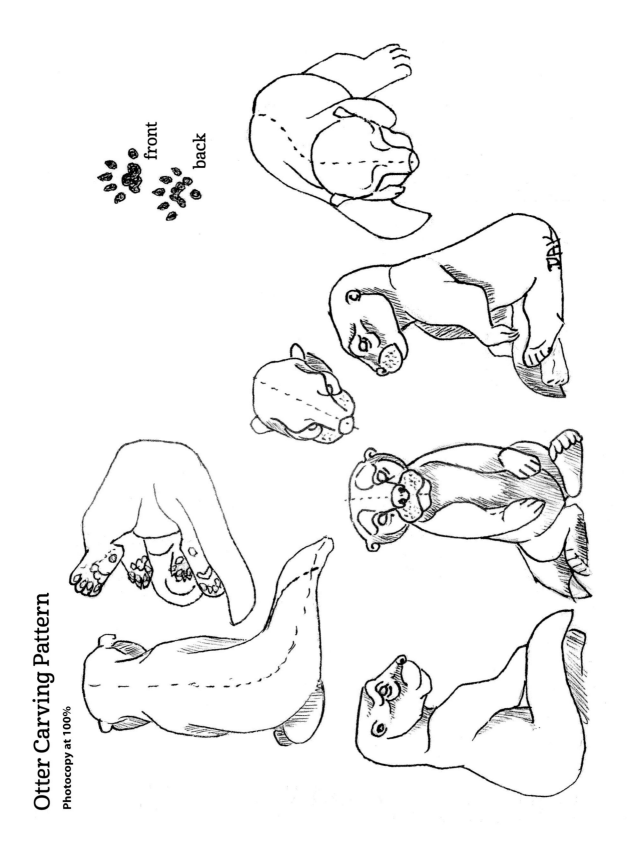

front

back

Otter Hair Tract Pattern

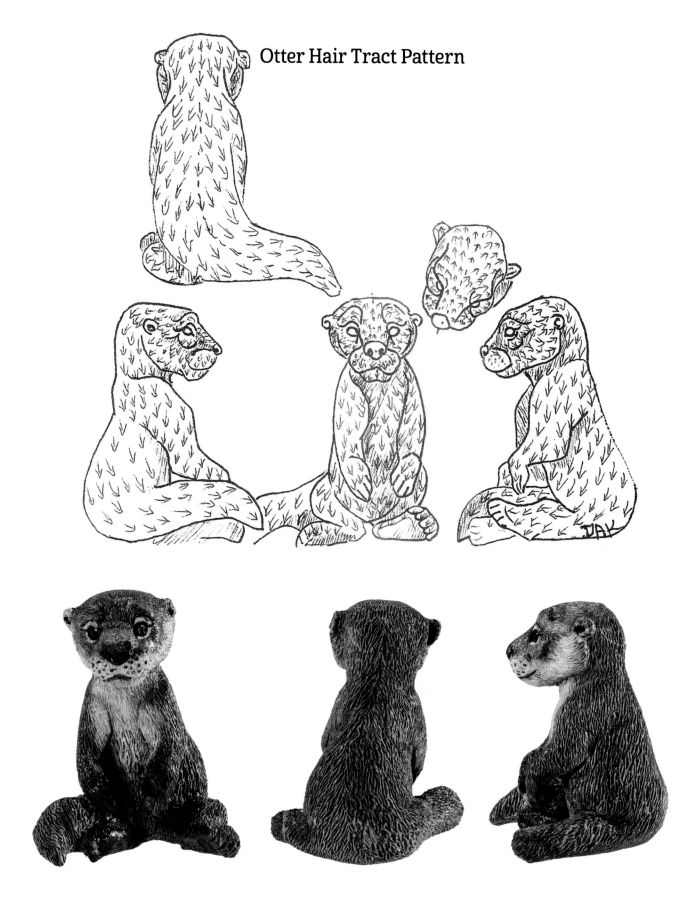

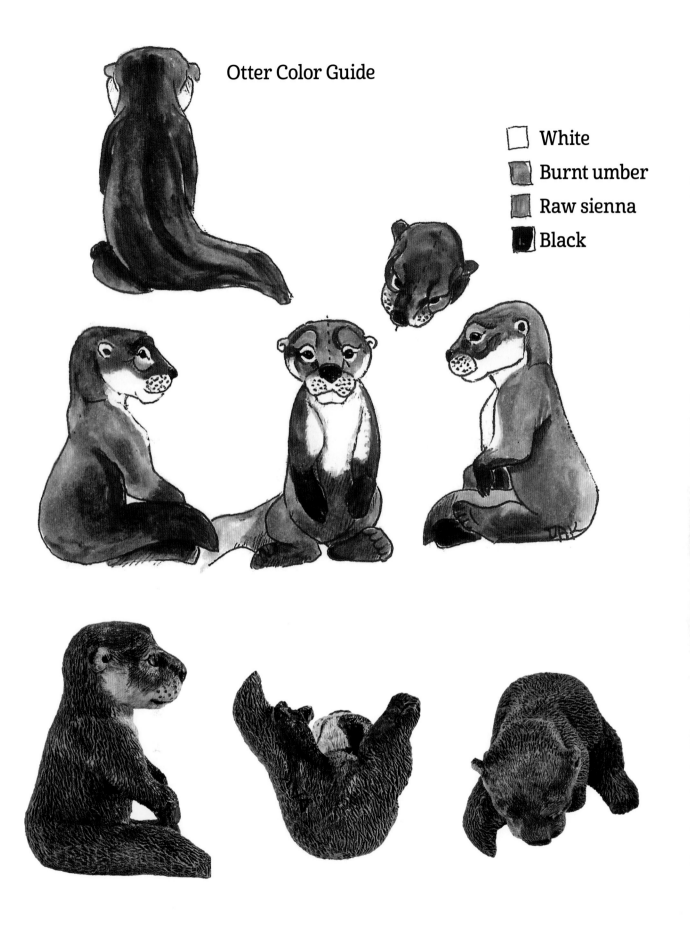

Otter Color Guide

☐ White

▨ Burnt umber

▨ Raw sienna

■ Black

Fawn

The white-tailed deer is the most abundant hoofed animal in North America. It lives in mixed woodlands, in second growth forests, and at the forest's edge. Young white-tailed deer are often regarded as the ultimate in innocence in the animal world. They are awkward and clumsy at first, as shown in the animated movie *Bambi*, yet they walk within hours of birth. Their bodies are short and their legs are long. They have beautiful white spots, between 295 and 305 spots on an average fawn, to help serve as camouflage until they have matured.

The white-tailed deer is the only Eastern deer with a tail that is white underneath and the same color as the deer's back on top. In addition to being very graceful, they are also very nervous and skittish. When startled into flight, a deer will raise its tail like sort of a flag to show the white below. To escape an enemy, it will often run downhill to get away faster.

Fawns are essentially odorless, and this offers protection from predators. They typically begin eating vegetation about two weeks after their birth. If there are twin fawns, the doe will separate them, usually placing them about 25 feet (7.6m) apart. About three to four weeks after their birth, the twins will be reunited. During fawns' early childhood, the does are usually within 100 yards (91m) at all times. While at rest, a fawn's heart beats about 175 times per minute. If frightened, its heart rate drops to about 60 beats per minute and its breathing becomes slow and shallow.

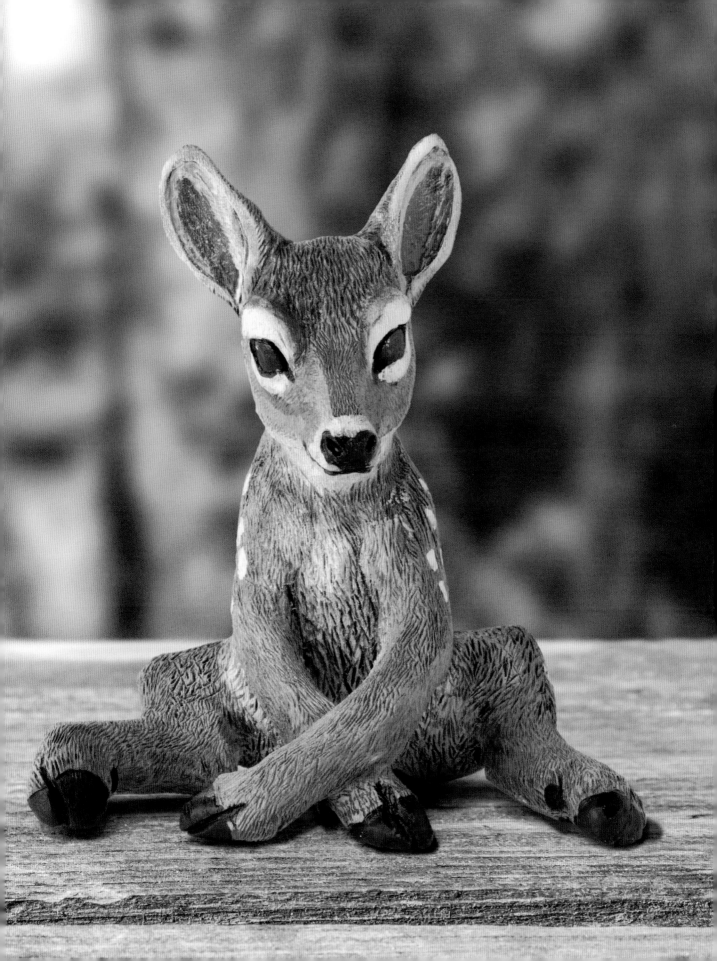

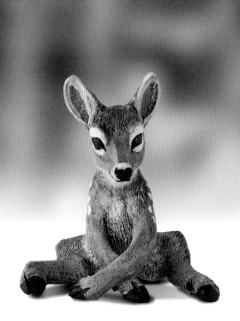

Texturing

• Tools: carving tools of choice (see page 29)

You can either leave the cut marks from shaping the fawn or smoothly sand the piece. Given the lack of heavy texture on the fawn, you don't need to texture it—you can go directly to the woodburning stage to give the illusion of furred areas.

Woodburning

• Tips: skew tip, writing tip, shading tip

With a skew tip, outline and burnish the eyes. Outline the mouth, hooves, and dew claws. Also burnish the hooves.

Use a writing tip to burn in the nostrils, using a squiggling motion on the nose pad. Next hollow out the ears. After drawing in the spots, referring to the pattern, use the writing tip to burn them in.

Use a shading tip to burn the rest of the body, following the flow shown on the hair tract pattern.

Painting

• Brushes: soft round brush, stiff-bristled brush, detail brush, toothpick
• Colors: black, burnt umber, white, raw sienna, honey brown, pewter gray

Following the color guide, prepare watered-down colors on your palette. Using a soft round brush, layer colors on the fawn until you reach the proper shades. Let dry.

Use a stiff-bristled brush for the drybrush process. Keep in mind that the paint isn't watered down for the drybrushing steps. Start out with white over the light areas. Then drybrush with honey brown over the areas that have been painted with raw sienna.

With a detail brush, following the color guide, paint the eyes, nose, hooves, and dew claws with black. Paint in pewter gray for the iris on the eye. Paint in white for the white spots, tail area, around the eyes, and inside the ears. Apply a white highlight to the top of each eye with a toothpick.

Fawn Carving Pattern

Photocopy at 100%

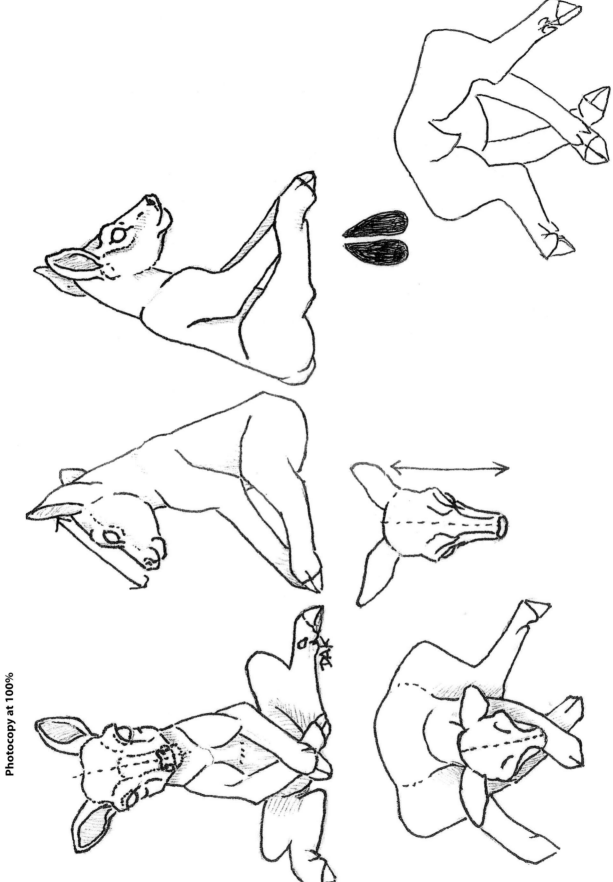

Fawn **53**

Fawn Hair Tract Pattern

Fawn Color Guide

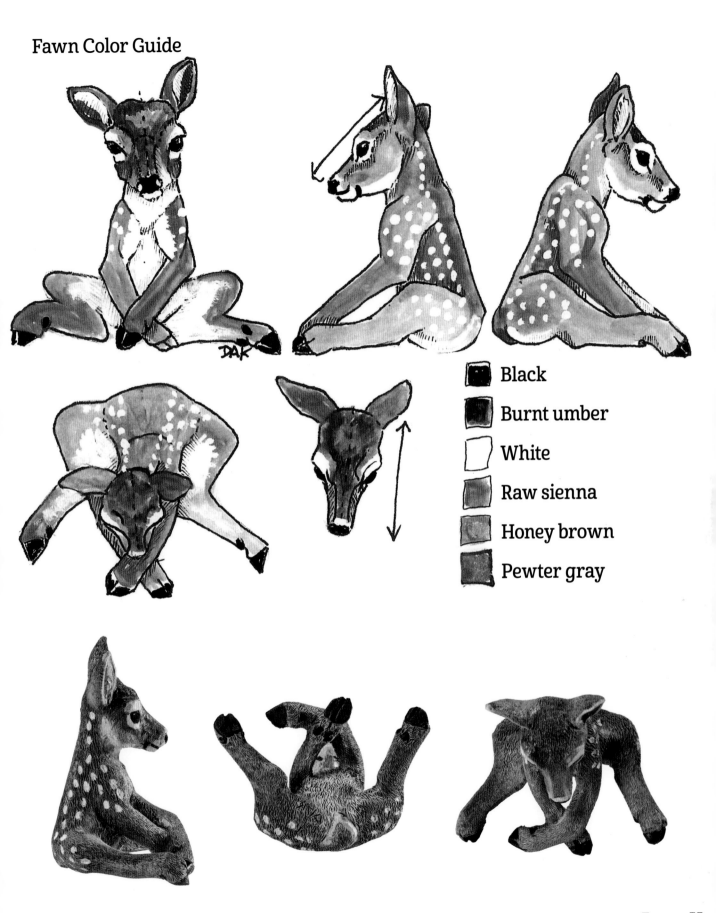

Black

Burnt umber

White

Raw sienna

Honey brown

Pewter gray

Kangaroo

Found in Australia and New Guinea, the gray kangaroo is one of the prettiest of the kangaroo family. These marsupials have strong back legs that allow them to bound far and fast, and they use their tails as tripods when standing. A kangaroo is unable to walk backwards, but it can jump three times its own height.

Kangaroos have a special pouch for their joeys, or young kangaroos. The gestation period is quite short, only around seven weeks. They carry the joey around in the pouch for a large part of the joey's childhood, until eventually the joey is too big to fit.

There are four different species of kangaroos. They are the red kangaroo, eastern gray kangaroo, western gray kangaroo, and antilopine kangaroo. A group of kangaroos is called a mob, a troop, or a court. They stay in these groups, which number three or four, although it's not uncommon to see a hundred kangaroos together. The red kangaroo is the largest kangaroo in the world. More kangaroos populate Australia than people.

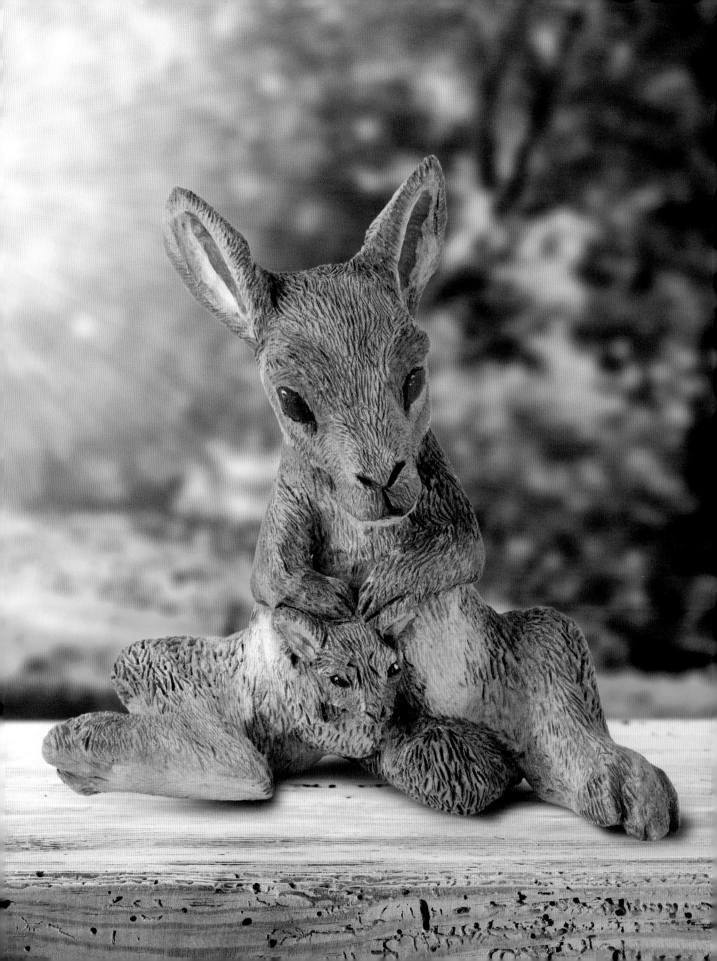

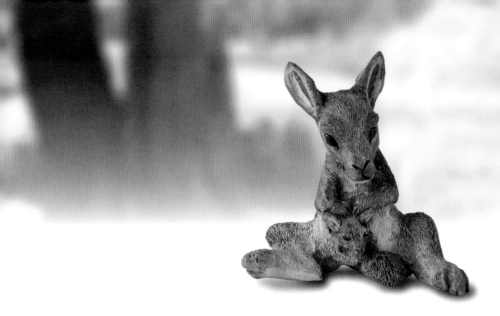

Texturing
- Tools: carving tools of choice (see page 29)

Leave the cut marks from the gouge you used, or sand the animal smooth to the shape you wish. The kangaroo doesn't have a heavy texture, so you can go directly to the woodburning stage for the finer hairs.

Woodburning
- Tips: skew tip, writing tip, shading tip

Using a skew tip and referring to the pattern, burn in the outline of the eyes and eyeballs. Burn in the outline of the nose, cleft, and mouth. Burn tiny hairs on the bridge of the nose, muzzle, and hair under the eyes down to the jaws. Burnish the claws on the feet.

Hollow out the ears and split the toes with a writing tip.

Use a shading tip to burn the rest of the body, following the hair tract pattern.

Painting
- Brushes: soft round brush, stiff-bristled brush, detail brush, toothpick
- Colors: vanilla, latte, elephant gray (made by mixing pewter gray and burnt umber), black, raw sienna

Following the color guide, prepare watered-down colors on your palette. With your soft round brush, apply the colors to the kangaroo until you reach your desired shades. Let the paint dry before proceeding.

Drybrush the piece with latte using a stiff-bristled brush.

Using a detail brush, apply black paint to the eyes, nose, and claws, using the color guide as reference. Apply a white highlight to the top of each eye with a toothpick.

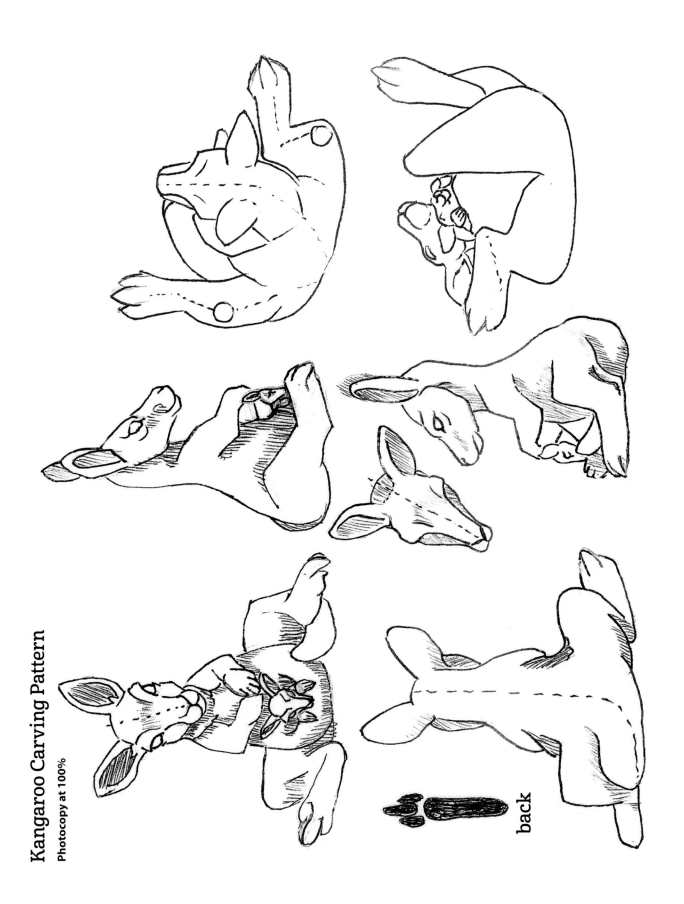

Kangaroo Carving Pattern

Photocopy at 100%

back

Kangaroo Hair
Tract Pattern

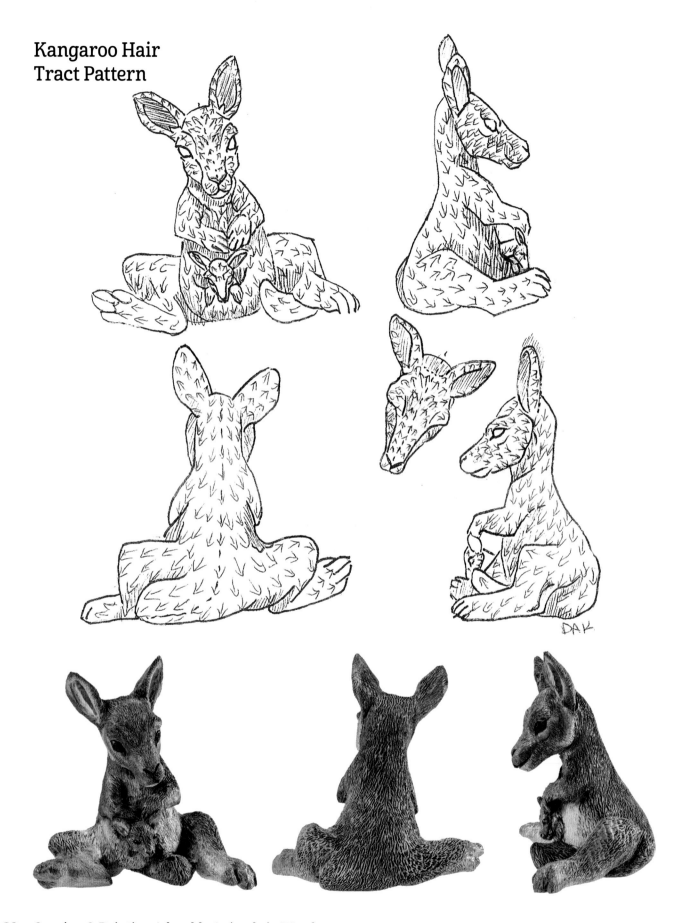

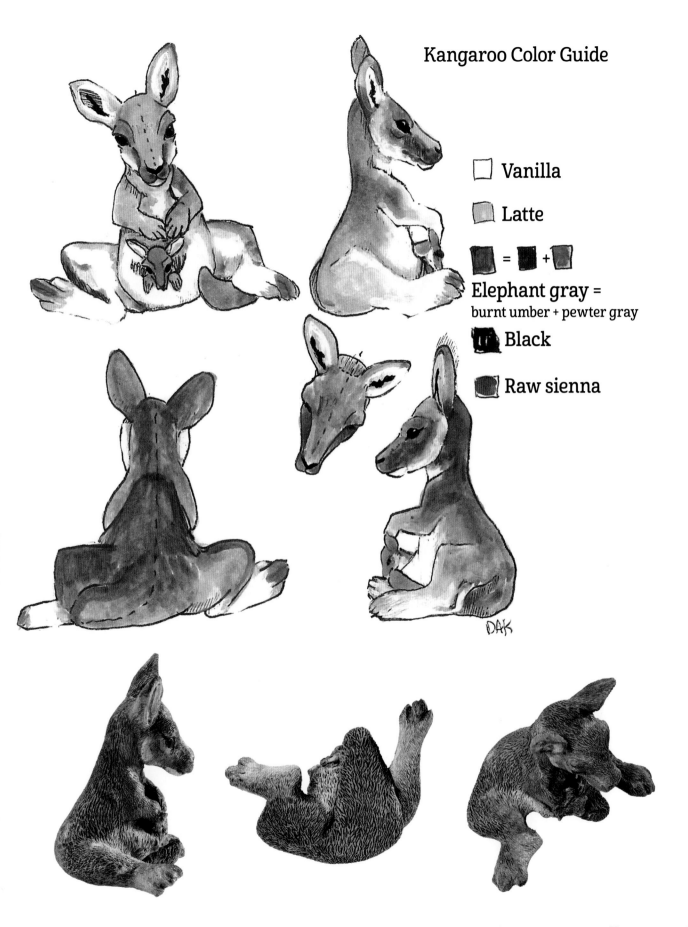

Kangaroo Color Guide

□ Vanilla

Latte

■ = ■ + ■

Elephant gray =
burnt umber + pewter gray

Black

Raw sienna

DAK

Elephant

A herd of African elephants is led by a dominant female. She is usually the oldest in the group, and she helps the young mothers learn how to be good mothers. Males are included in the group until they reach the age of about fifteen years. The young help with the younger calves in playing and babysitting, all under the watch of the vigilant matriarch.

The foot of the elephant is a spongy pad with four to five toes and toenails. This pad acts as a cushion for the weight the elephant bears. There are extra muscles in an elephant's neck to support its large head. The gestation period for expectant mothers is about twenty-two months. A mother elephant has a calf about every four to six years, and each calf can stand within an hour of being born. The life span of the elephant ranges from fifty to seventy years, with the oldest on record living to a ripe old age of eighty-six.

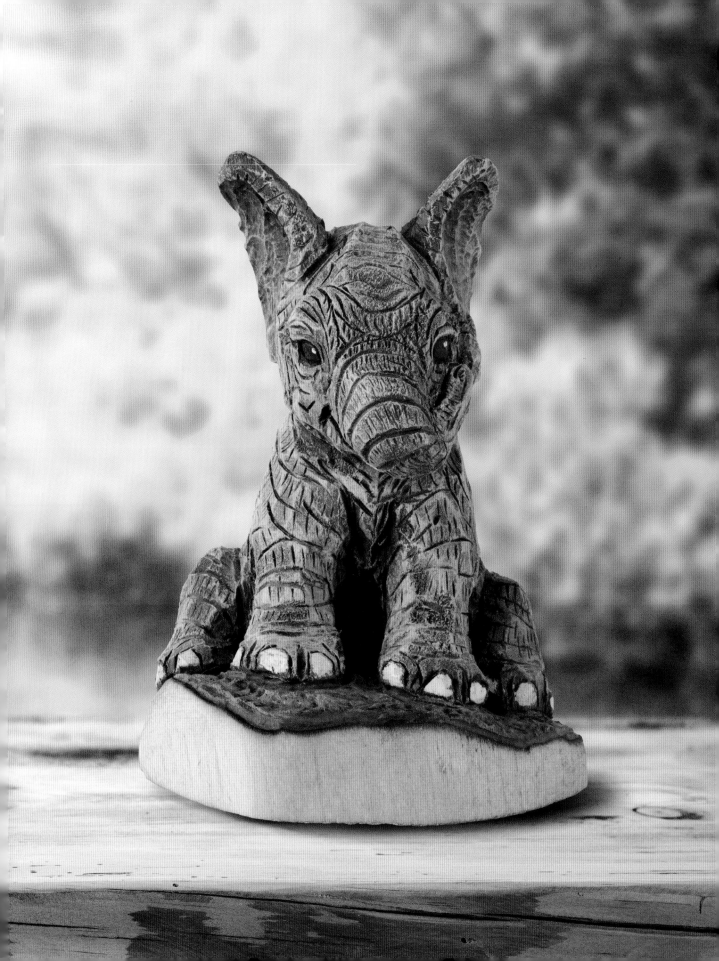

Texturing

- Tools: carving tools of choice (see page 29)

It's your choice to either leave the cut marks or smooth the surface with sanding. Either way, you'll need to add the distinctive elephant wrinkles. Use a V-tool if you want to use hand tools and a disc-shaped rotary bit if you want to use rotary tools.

Mark in the wrinkles, using the pattern as a guide. Apply your tool of choice at a thirty- to forty-five-degree angle to show the crease of the wrinkle. Gently press into the surface, increasing the pressure. When your tool gets to the end of the wrinkle, ease up the pressure. Continue this until all of the wrinkles are carved.

Woodburning

- Tips: skew tip, writing tip

With a skew tip, outline the eyes and burnish the eyeballs and along the mouth. Burn in the smaller wrinkles and outline the toenails, using the pattern as a reference.

Using a writing tip, follow the texture of the wrinkles to burn each of them in. Use the squiggle technique on the rest of the body.

Painting

- Brushes: soft round brush, stiff-bristled brush, detail brush, toothpick
- Colors: elephant gray (made by mixing burnt umber and pewter gray), pewter gray, fawn, vanilla, black, English ivy

Prepare watered-down colors on your palette, following the color guide. Using a soft round brush, apply the colors to the elephant. Layer the colors until you reach the proper shades. Allow the piece to dry before continuing.

With a stiff-bristled brush, drybrush the piece with fawn. Remember, don't water down the paint for drybrushing.

Apply the details with a detail brush, following the color guide. Paint the eyes with black, the toenails with vanilla, and, with a toothpick, put a vanilla highlight on the top of each eye.

The base can be colored with English ivy.

Elephant Carving Pattern

Photocopy at 100%

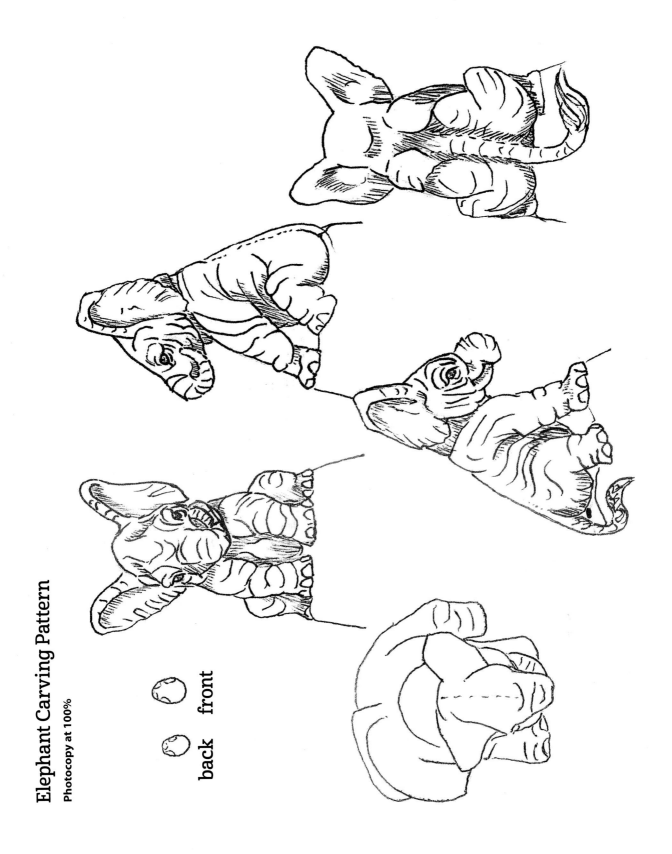

back front

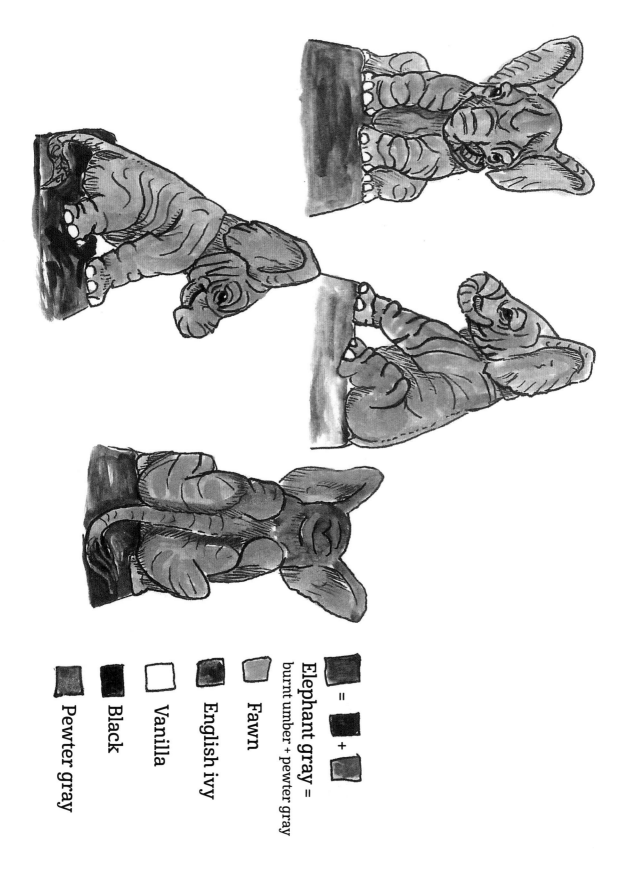

Elephant gray =
burnt umber + pewter gray

= ■ + ■

Fawn

English ivy

Vanilla

Black

Pewter gray

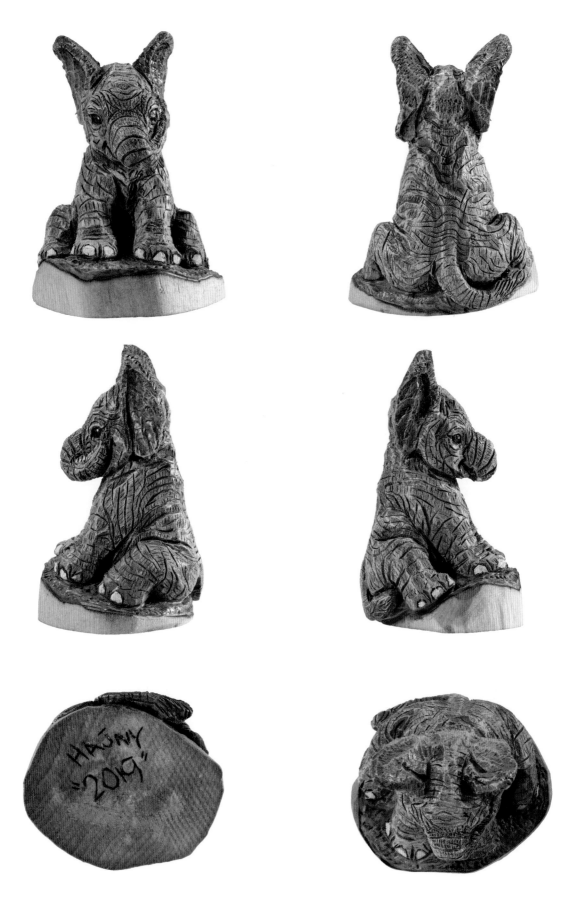

Fox

The red fox is the most common fox, well known for its beauty. They can actually be several different colors, including black, silver, red, and black mix, but they always have a white-tipped tail. Their cleverness has given rise to the expression "as sly as a fox."

A group of foxes is called a skulk or leash. The whiskers on their legs and faces help them to navigate. The male of the species is referred to as a dog fox, and the female is called a vixen. They are primarily solitary animals, but the male will bring in food for the pups, and other vixens will sometimes assist a mother in caring for young. Their dens are normally barrows underground, but they can also be found in above-ground hollows.

They are incredibly adaptive animals, with successful colonies all over the world. Foxes' vertical pupils help with their night vision, and they possess excellent hearing—they can hear a ticking watch from a distance of 40 feet (12m). The fox does not chew its food; instead, it uses its shearing teeth to cut the meat into manageable pieces that it then swallows.

Red foxes aren't much taller than a basset hound. The males are larger than the females. The foxes that are located in the southern regions of the United States are smaller than those living in the northern regions. A fox's tail is as long as its body, and its feet have fur in between the foot pads, which allows for better grip on ice and snow. The gray fox is the only canine with retractable claws.

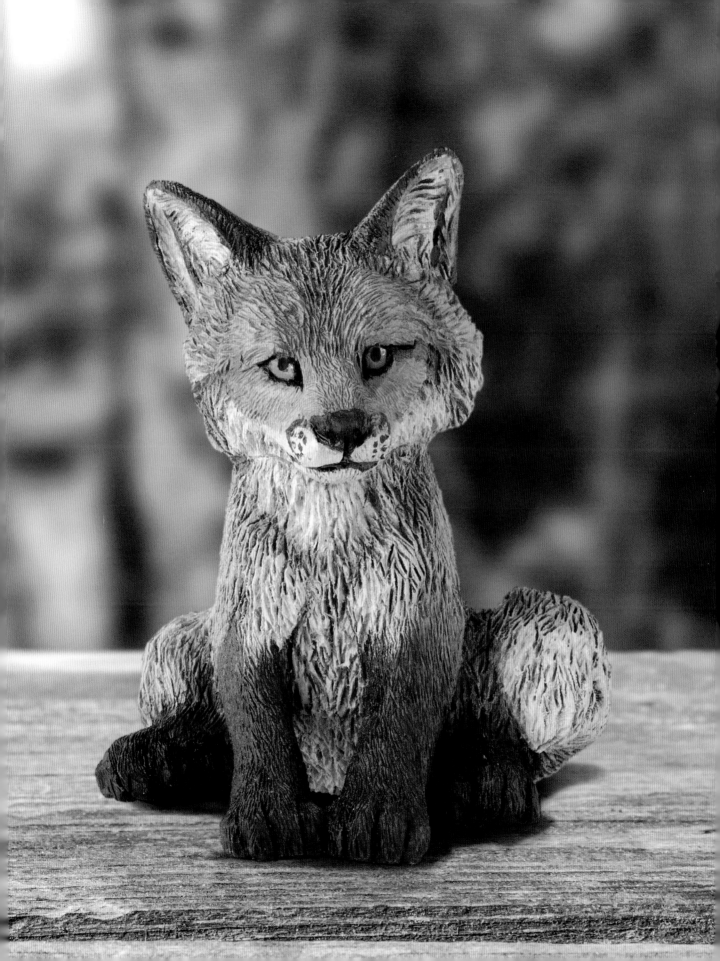

Texturing

- Tools: carving tools of choice (see page 29)

You can either sand the piece or leave it as is before texturing. If using hand tools, you will need a #5, #6, or #7 gouge. A V-tool will also work well. If you choose to use power, a disc-shaped or ball-shaped rotary bit will work.

Use the hair tract pattern to draw the direction of the fur. For whichever tool you've chosen, apply the tool to the surface at a thirty- to forty-five-degree angle, increasing pressure as you push. When the tool gets to the end of the marked area, ease up on the pressure. Keep repeating this until you are done with the body. I would recommend using a gouge or ball-shaped rotary bit first, followed by a V-tool or disc-shaped rotary bit, until you get the desired results.

Woodburning

- Tips: skew tip, writing tip, shading tip

Using a skew tip, outline the eyes, nose, cleft, and mouth. Draw the pupils and burn them in. With tiny stabs, burn in the top of the nose bridge.

With a writing tip, hollow the ears and draw whisker dots, burning lightly. Burn in the nostrils and squiggle in the texture on the nose pad, referring to the pattern. Squiggle in the front pads that are shown on the pattern.

Use a shading tip to burn the fur on the body, as shown on the hair tract pattern.

Painting

- Brushes: soft round brush, stiff-bristled brush, detail brush, toothpick
- Colors: honey brown, moccasin brown, white, tan, burnt umber

Following the color guide, prepare watered-down colors on your palette. With a soft round brush, layer the colors until you reach the desired shades. Allow to dry.

Use a stiff-bristled brush to drybrush white on the lighter areas and honey brown on the rest of the fox. Remember, don't water down the paint for drybrushing.

Use a detail brush to paint in the eyes, nose, ears, and foot pads with black. Use the color guide for assistance. With a toothpick, apply black to the whisker dots and the pupils of the eyes. Moccasin brown should be used for the irises of the eyes. Finally, put a white highlight on the top of each eye with a toothpick.

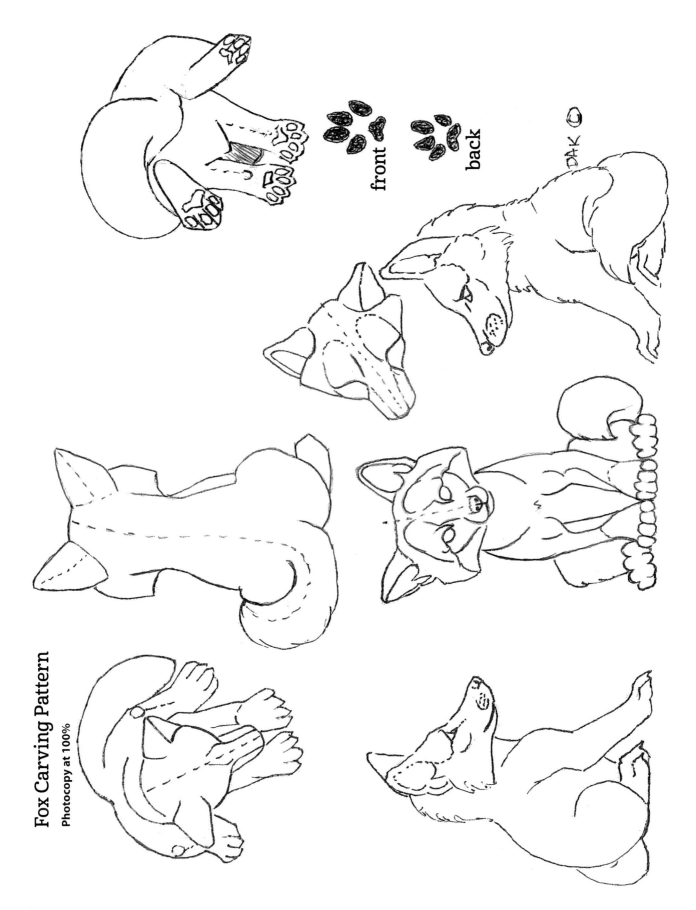

front

back

Fox Carving Pattern

Photocopy at 100%

Fox Hair Tract Pattern

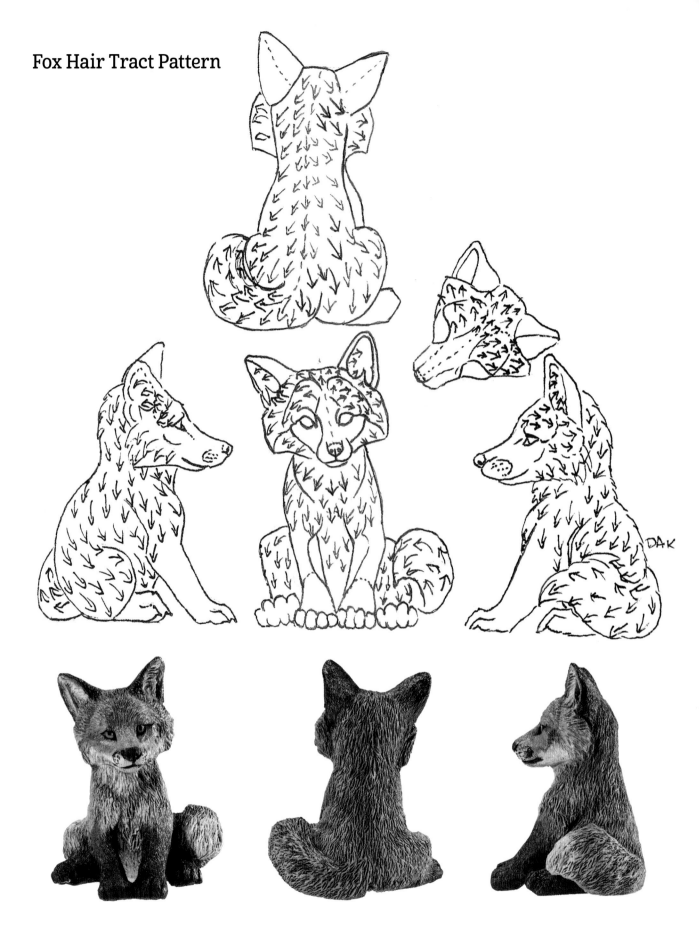

Fox Color Guide

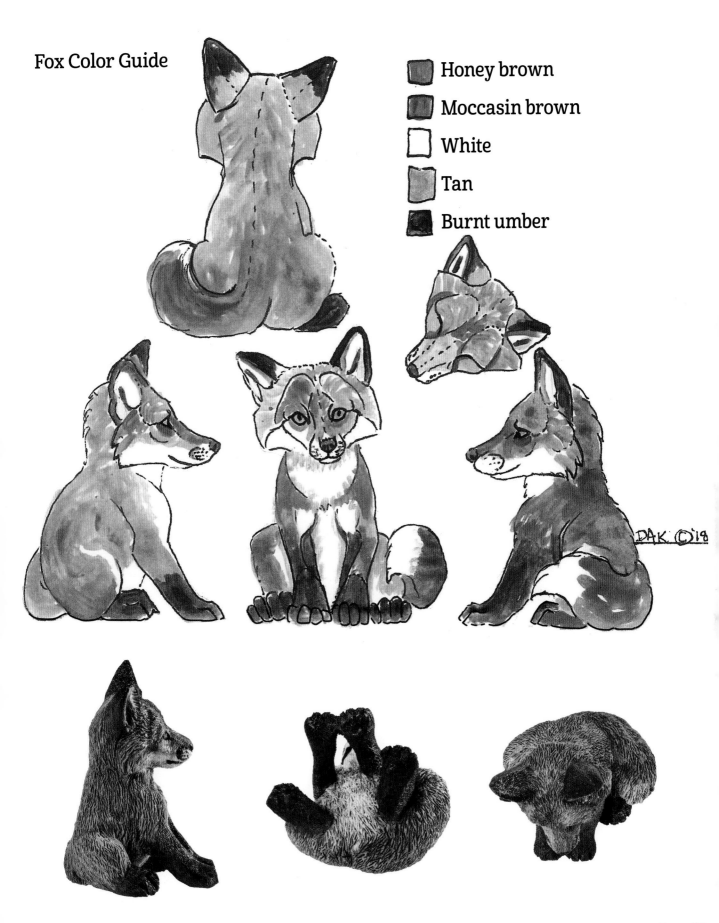

- Honey brown
- Moccasin brown
- White
- Tan
- Burnt umber

DAK ©'18

Chipmunk

These little guys are constantly on the move. They dart around and always seem busy gathering nuts, seeds, and acorns for the winter. Even so, chipmunks may spend as much as fifteen hours a day sleeping. Because of their small size, they are desirable prey for other carnivores and must be on the lookout constantly. They humor us with their energetic antics.

A chipmunk is the smallest member of the squirrel family. There are twenty-five different species of chipmunks in North America. They prefer to live underground, and their tunnel system can reach from 10–30 feet (3–9m) in length. They are not picky eaters—their diet consists of such things as nuts, berries, seeds, mushrooms, eggs, insects, frogs, lizards, and baby birds, among many other items. From late October through March or April, chipmunks hibernate. They do wake up occasionally to dip into their stockpile of nuts and seeds and may even venture outside for short stints during their hibernating period. They mature quite quickly after being born, leaving the nest at just four to six weeks.

Texturing

- Tools: carving tools of choice (see page 29)

You can either sand the piece or leave the cut marks before texturing. You can either use a #5, #6, or #7 gouge for the chipmunk. If you are using power tools, you will need a ball-shaped rotary bit.

Draw the direction of the fur, using the hair tract pattern. With your chosen tool at a thirty- to forty-five-degree angle, apply pressure at contact. When the tool reaches the end of each marked area, lighten up the pressure. Keep repeating this until you have textured the entire animal.

Woodburning

- Tips: skew tip, writing tip, shading tip

Referring to the hair tract pattern, use a skew tip to outline the eyes and burnish the eyeball. Outline the cleft and mouth. Burn in the short hairs on top of the nose and down on the muzzle.

With a writing tip, hollow out the ears, then mark the whisker dots and burn them. Draw the dark stripes and burn them like hair. You may have to burn the stripes a little darker. Use a squiggle burn for the foot pads.

Use a shading tip to burn the rest of the body, referring to the hair tract pattern.

Painting

- Brushes: soft round brush, stiff-bristled brush, detail brush, toothpick
- Colors: vanilla, khaki, moccasin brown, burnt umber, black

Following the color guide, prepare watered-down colors on your palette. With a soft round brush, layer the colors until you reach the proper shade for each area. Allow the piece to dry.

With a stiff-bristled brush, use white to drybrush the piece. Remember, don't water down the paint for drybrushing.

Following the color guide and using a detail brush, paint in the eyes, nose, stripes, and whisker dots with black paint. You can also use a toothpick for the whisker dots. Apply a white highlight to the top of each eye with a toothpick.

Chipmunk Carving Pattern

Photocopy at 100%

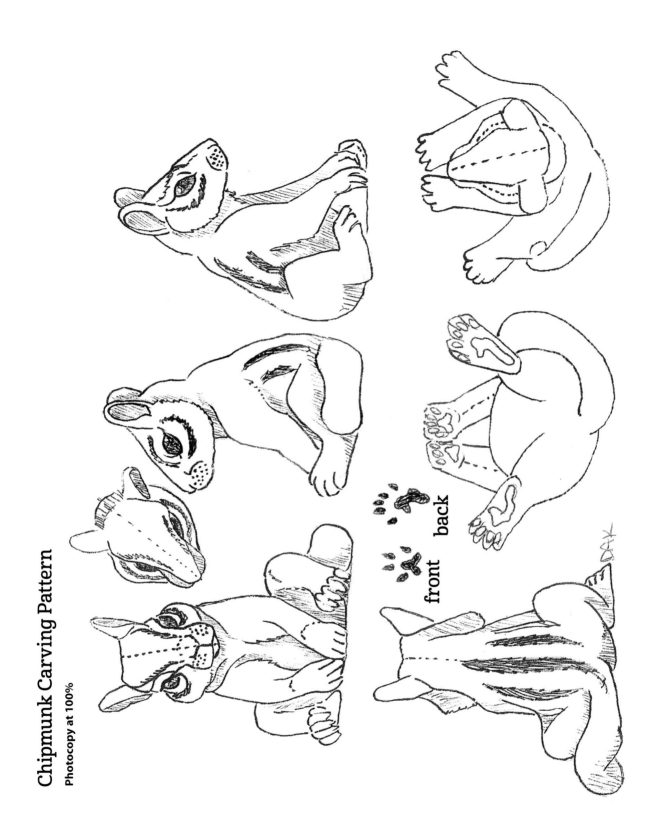

front back

Chipmunk Hair Tract Pattern

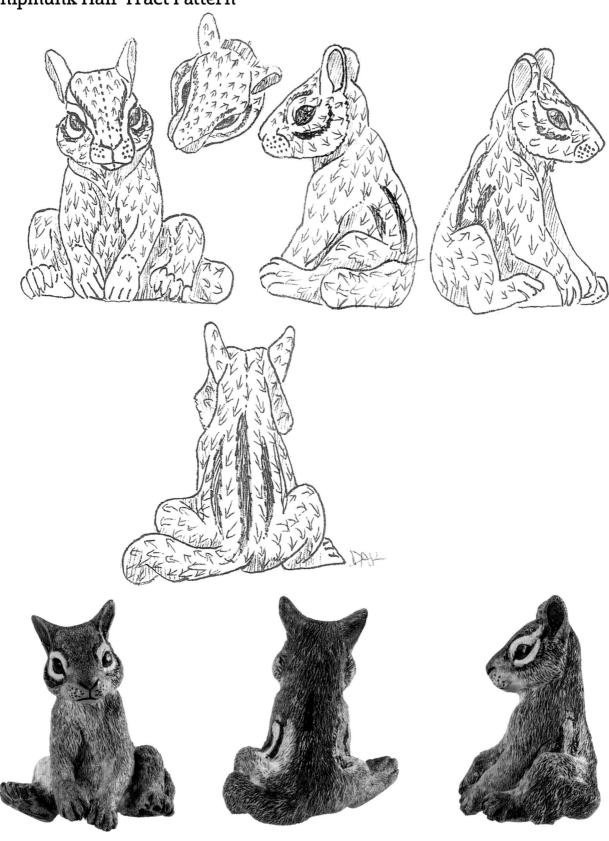

Chipmunk Color Guide

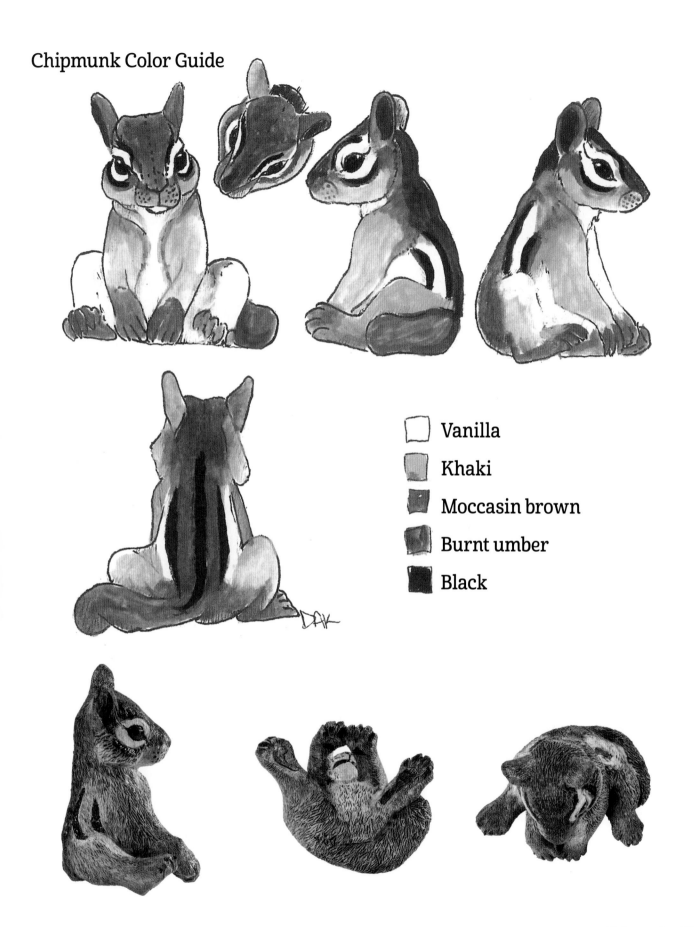

- Vanilla
- Khaki
- Moccasin brown
- Burnt umber
- Black

Bobcat

The bobcat is only found in North America and is the most common wild cat. Its name comes from its bobbed or stubby tail. It has very distinct spotting and muttonchops. Even though it is small in stature, it is very feisty. The adult bobcat is about 2 feet (0.6m) tall and weighs around 30 pounds (13.6kg). Bobcats don't like to be around people, so it's a treat to catch a glimpse of one of them in the wild.

Although most of their prey is smaller, bobcats can take down a fully grown white-tailed deer. They leave the parts of the deer (or other large prey) that they can't immediately eat in a cache. Their territories can range up to 18 miles (29km) wide. One bobcat will often have several dens due to the size of its territory. This also allows the mother bobcat to move her kittens to other dens to protect them from predators. The female of the species is more aggressive, especially toward other females. Bobcats possess exceptional sight and hearing.

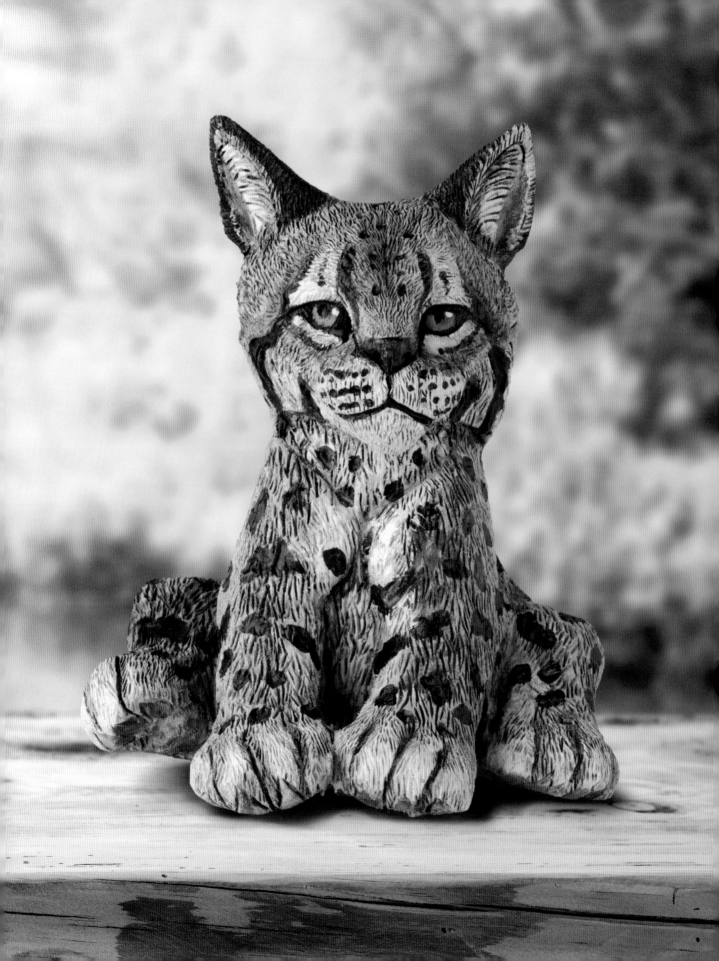

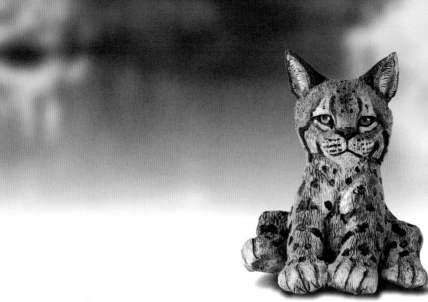

Texturing

• Tools: carving tools of choice (see page 29)

You can either sand the piece or leave it as it is before continuing to the texturing. I used a hand gouge for my texturing. If you want to as well, you can use a #5, #6, or #7. If you want to use a rotary tool, a ball-shaped rotary bit would work well.

First, draw the direction of the fur, referring to the hair tract pattern. Apply your chosen tool to the surface at a thirty- to forty-five-degree angle. Apply pressure at the contact point. When the tool gets to the end of each marked area, lighten up the pressure. Continue this process until your bobcat is fully textured.

Woodburning

• Tips: skew tip, writing tip, shading tip

With a skew tip, outline the eyes, nose, cleft, and mouth. Mark the pupils and burn them in with the point of the tip. Burn with a stab-pull motion on the bridge of the nose as well as under and over the eyes.

Hollow the ears, whisker dots, and spots around the body using a writing tip and referring to the pattern. Squiggle the foot pads.

Following the hair tract pattern, use a shading tip to burn the rest of the body, even over the texturing that you have done.

Painting

• Brushes: soft round brush, stiff-bristled brush, detail brush, toothpick
• Colors: latte, honey brown, black, white, orange

Using the color guide as reference, prepare watered-down colors on your palette. Apply them to the bobcat using a soft round brush, layering the colors until you achieve the proper shades. Allow the piece to dry.

Drybrush the entire piece with white using a stiff-bristled brush. Remember, don't water down the paint for drybrushing.

Paint in details like the eye color, nose, and spots using a detail brush, referring to the color guide. On the spots, you can either use the detail brush or a toothpick. The eye color is a honey, white, and black mixture; the nose color is orange; and the pupils are black. Apply a white highlight to the top of each eye with a toothpick.

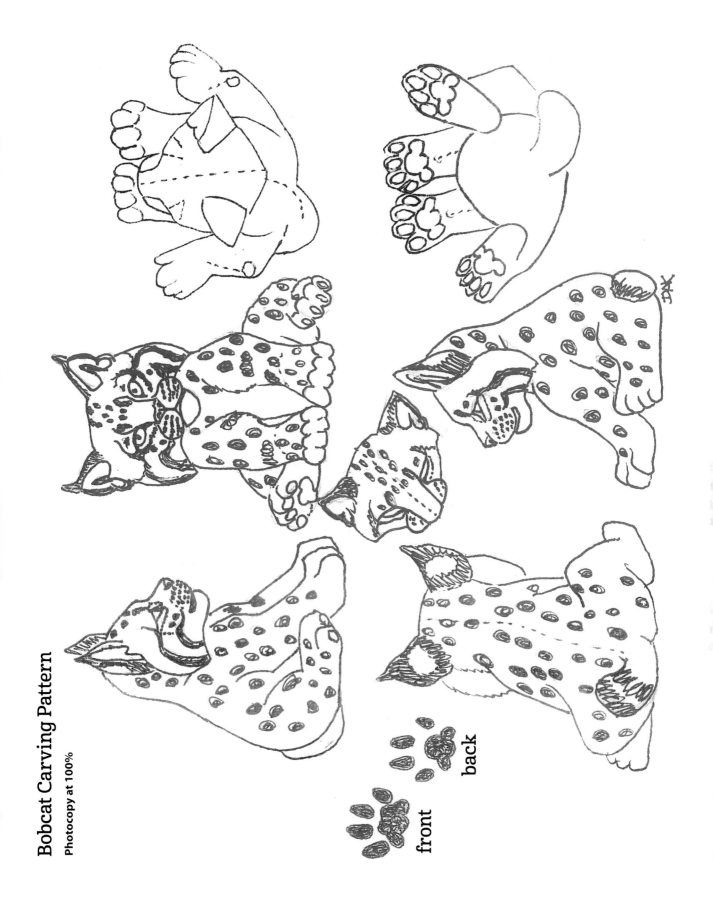

Bobcat Carving Pattern
Photocopy at 100%

front

back

Bobcat Hair
Tract Pattern

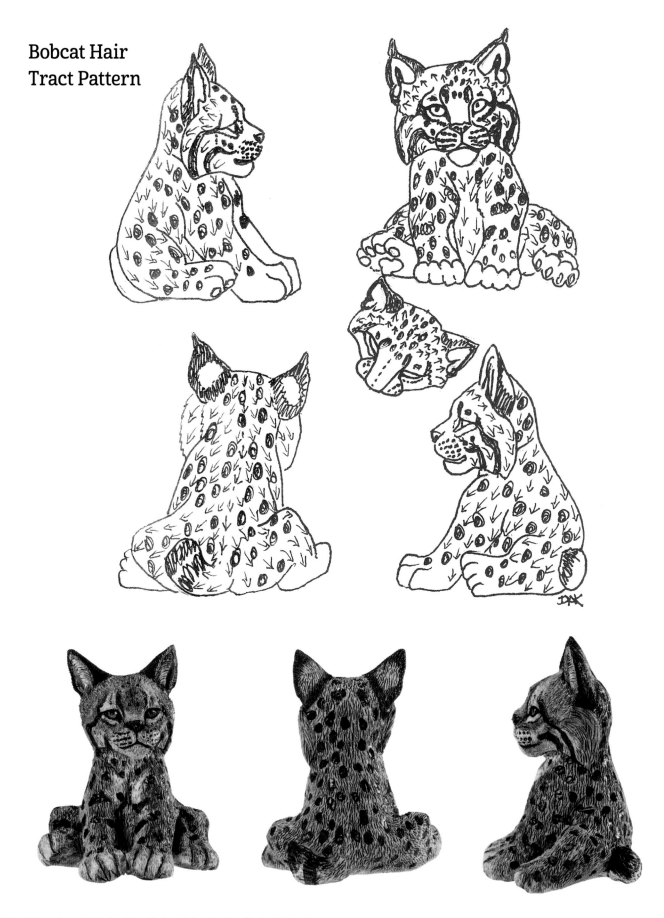

Bobcat Color Guide

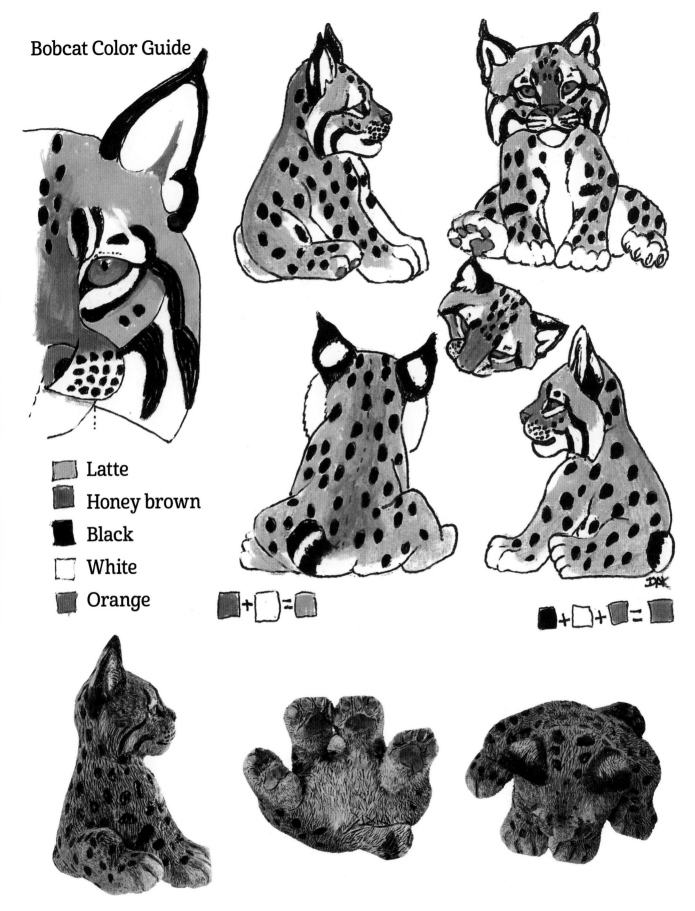

Latte
Honey brown
Black
White
Orange

Donkey

These stubborn, spunky little animals will size up their adversaries before making a decision on their next course of action. They are fearless and have been seen taking on threats as big as mountain lions. In most instances, they will rely on their powerful kick as their preferred attack.

Donkeys were originally found in Africa and the Middle East some 5,000 years ago. China has the largest donkey population in the world. The male donkey is called a jack and the female a jenny. The gestation period for a baby donkey is right at 365 days.

A donkey has excellent memory—it can recall another donkey or a place it has previously been to as far back as twenty-five years. In desert conditions, a donkey is capable of hearing another donkey as far as 60 miles (97km) away. A donkey will never get involved in any activity it senses as being unsafe—if it senses something wrong while traveling, it will dig in its heels and not move, so take heed!

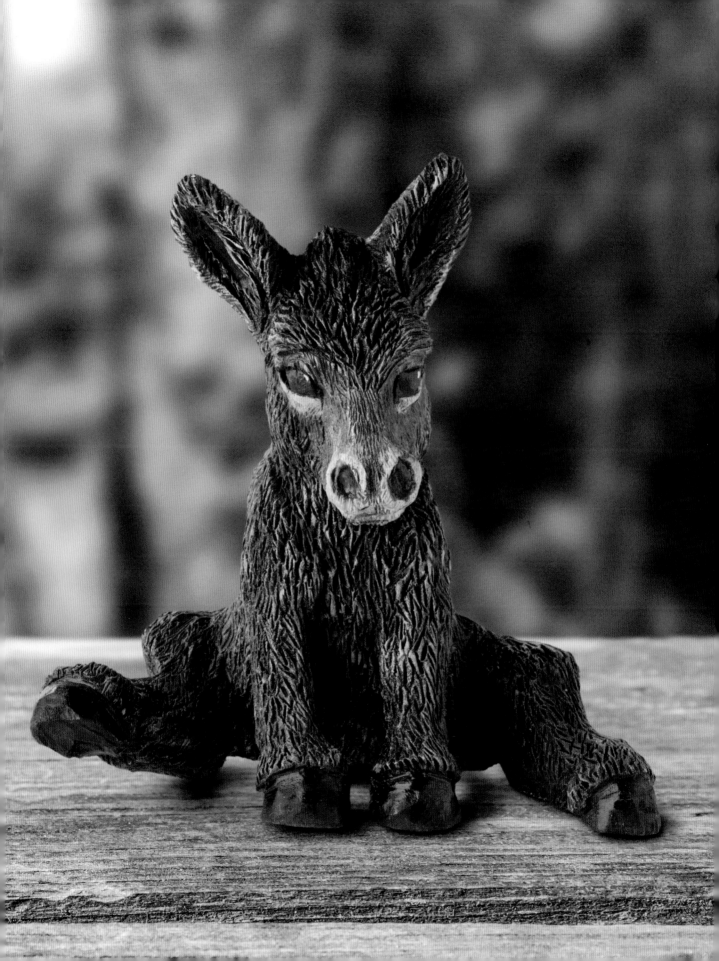

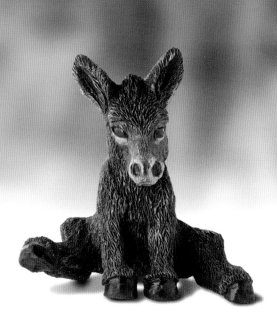

Texturing

- Tools: carving tools of choice (see page 29)

Leave the cut marks visible from the figure you have carved, instead of sanding it. You can use either a V-tool or disc-shaped rotary bit for the texture.

Draw the direction of the fur, using the hair tract pattern as reference. Apply your chosen tool to the surface at a thirty- to forty-five-degree angle. Gently press into the surface, increasing pressure as you push. When your tool gets to the end of the mark, ease up the pressure. Repeat this process until you have fully textured the donkey.

Woodburning

- Tips: skew tip, writing tip, shading tip

Use a skew tip to outline the eye, burnish the eyeball, and mark the mouth. Also use it to burn in the little hairs around the face as well as to burnish the hooves.

Use a writing tip to burn in the nostrils and the inside of the ears.

Referring to the hair tract pattern, use a shading tip to burn the rest of the body.

Painting

- Brushes: soft round brush, stiff-bristled brush, detail brush, toothpick
- Colors: white, burnt umber, raw sienna, black

Following the color guide, prepare watered-down colors on your palette. With a soft round brush, layer the colors on the donkey until you reach the desired shades. Let dry before continuing.

Use a stiff-bristled brush to drybrush the piece with raw sienna. Remember, don't water down the paint for drybrushing.

Following the color guide, use a detail brush for the eyes, nostrils, and hooves, using black for each. Apply a white highlight to the top of each eye with a toothpick.

Donkey Carving Pattern

Photocopy at 100%

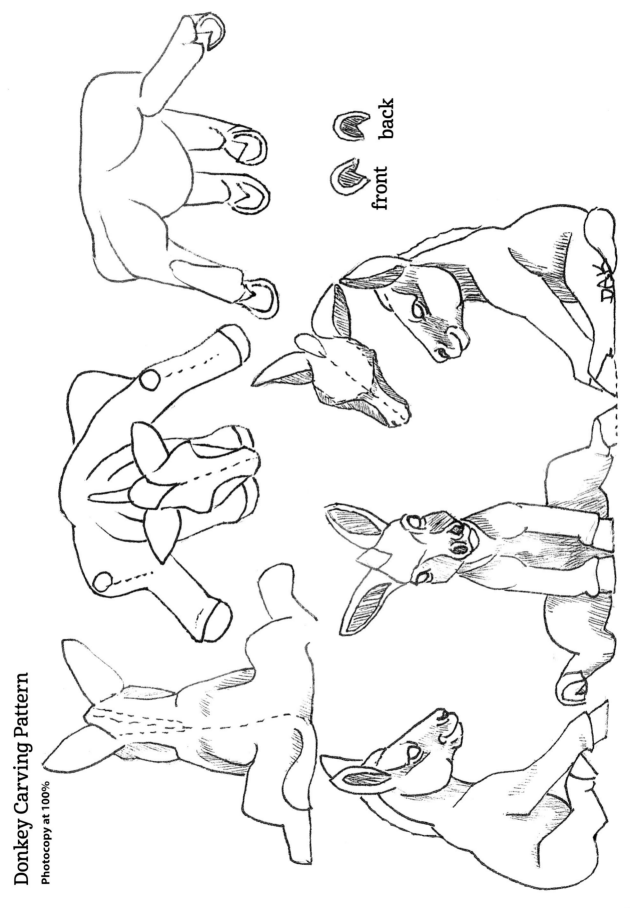

front back

Donkey Hair Tract Pattern

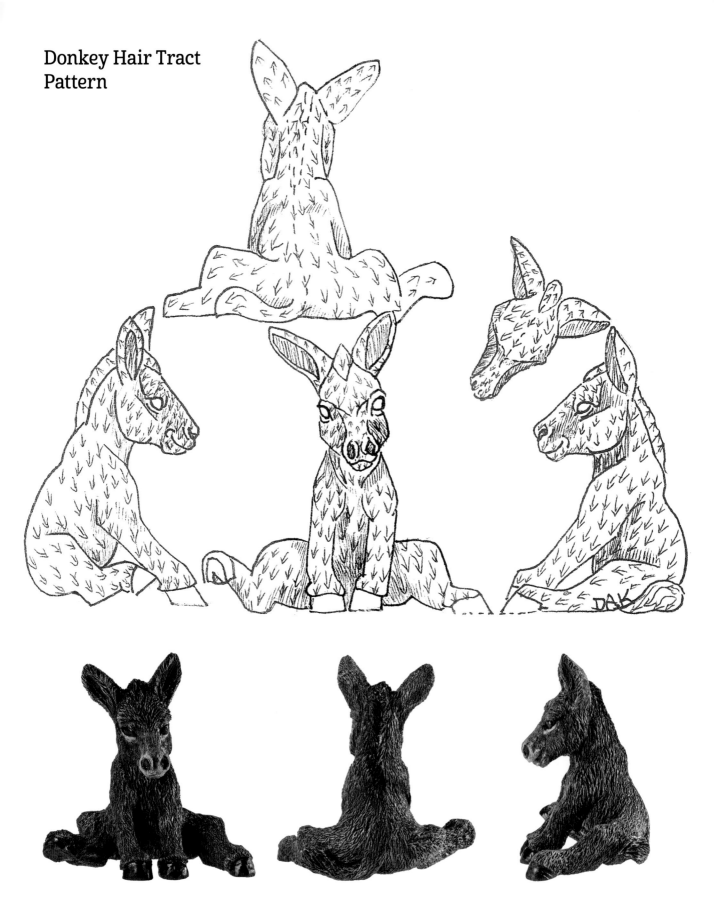

Donkey Color Guide

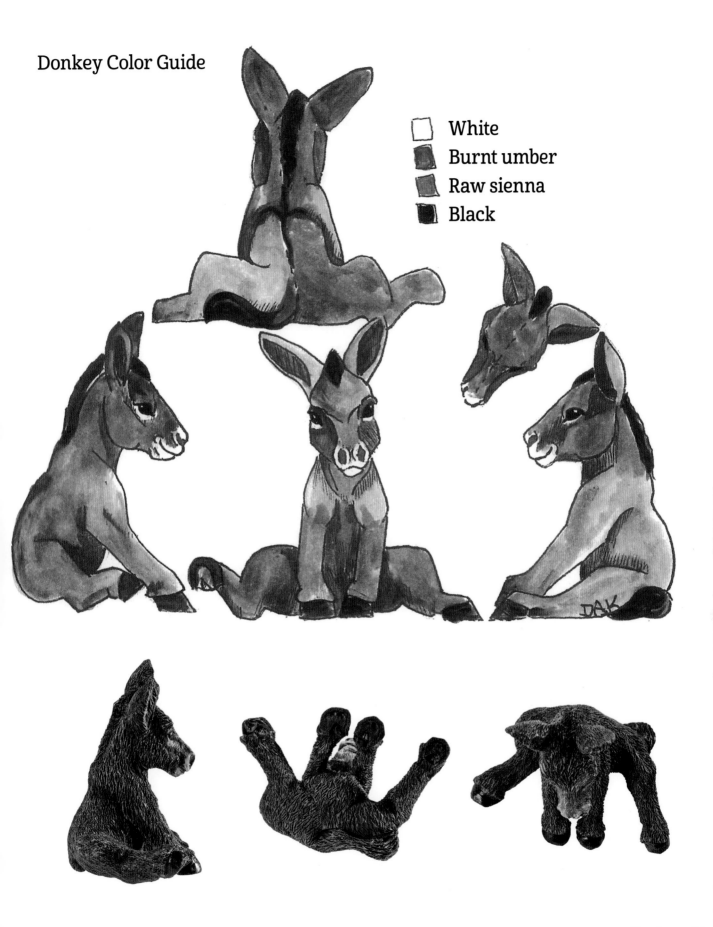

- ☐ White
- ■ Burnt umber
- ■ Raw sienna
- ■ Black

Raccoon

The mischievous raccoon is famous for its nighttime raids on trashcans and for fastidiously washing its food. It can find a home almost anywhere, from the suburbs to the woodlands. Its secret to survival lies in its intelligence, its ability to eat a wide variety of foods, and its agile hands. These little bandits are a joy to carve.

The raccoon was named for its dexterous hands. The Aztecs named it "mapachitli," which means "one that takes everything in its hands." It relies on its paws and sense of touch to find food. Its front paws have four times more sensory receptors than its back paws.

Relatives of the ringtail coati and panda, raccoons are gray with a black face mask and a distinctive ringed tail. The black around their eyes helps them see more clearly by allowing in less peripheral light, especially at night, when they are most likely to be out and about. A raccoon has two coats: a brown inner coat that is wooly and warm, and an outer coat with long black and white hairs that protect it from the wind. These guard hairs are very smooth, and water runs off them easily, keeping the raccoon warm and cozy.

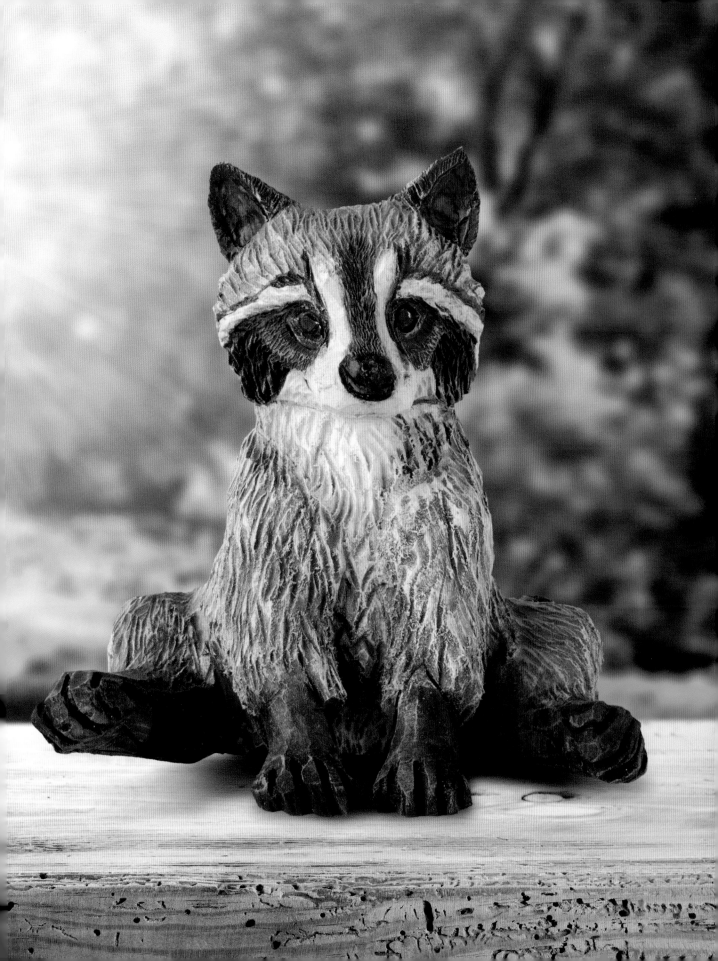

Texturing

- Tools: carving tools of choice (see page 29)

You can either sand the piece or leave the cut marks and proceed to texturing. The tools I have used for texturing the raccoon are a #5, #6, or #7 gouge and a ball-shaped rotary bit.

Draw the direction of the fur, referring to the hair tract pattern. Apply your chosen tool to the surface at a thirty- to forty-five-degree angle, increasing the pressure at contact. When the tool reaches the end of the marked area, ease up. Continue repeating this process until you are finished.

Woodburning

- Tips: skew tip, writing tip

Use a skew tip first, following the hair tract pattern. Burn the mask and the top of the nose bridge. Hold the burner with an eighty- to ninety-degree angle. Next, outline the nose pad, cleft, and mouth. Outline the eyes and burnish the eyeballs with the side of the skew tip, pulling it sideways across the surface of the eye. Continue using the skew tip to burn the fur on the body.

Use a writing tip to first mark and then burn the nostrils. Squiggle in the texture of the nose pad, using the pattern as a reference.

Painting

- Brushes: soft round brush, stiff-bristled brush, detail brush, toothpick
- Colors: pewter gray, raw sienna, black, white

Prepare the watered-down colors on your palette, following the color guide. Using a soft round brush, apply layers of color until you achieve the proper shades on your raccoon. Let the paint dry before proceeding.

Use a stiff-bristled brush to drybrush the raccoon with white. You can drybrush the entire raccoon, because you will be detailing after this. Remember, don't water down the paint when drybrushing.

Next, follow the color guide and use a detail brush to paint the eyes, nose, eyepatch, ears, and stripes on the tail with black. Apply a white highlight to the top of each eye with a toothpick.

FOX CHAPEL
PUBLISHING

FOX CHAPEL PUBLISHING
903 SQUARE ST
MOUNT JOY PA 17552–1911

FREE Pattern OFFER!

GET Creative with these Fantastic Patterns!

YES! Please send me the Free Pattern indicated below

☐ Woodcarving ☐ Scroll Saw ☐ Pyrography ☐ Woodworking ☐ Woodturning

Name

Address City

State/Prov. Zip

Country

Email

BONUS Enter your email address to receive more free patterns and special offers!

Return card or complete online for instant access to free patterns:
www.foxchapelpublishing.com/free-pattern

Raccoon Carving Pattern

Photocopy at 100%

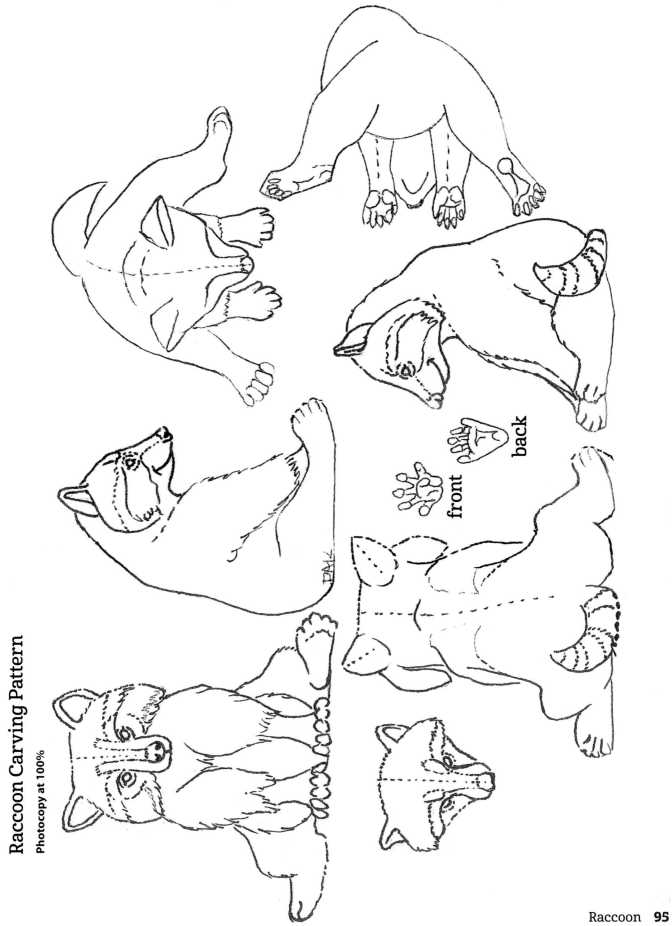

front

back

Raccoon Hair Tract Pattern

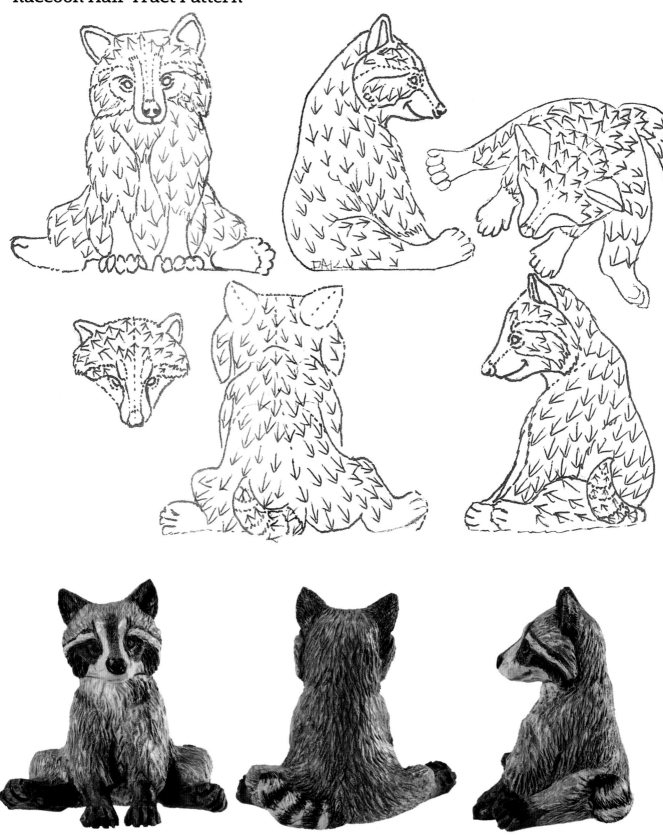

Raccoon Color Guide

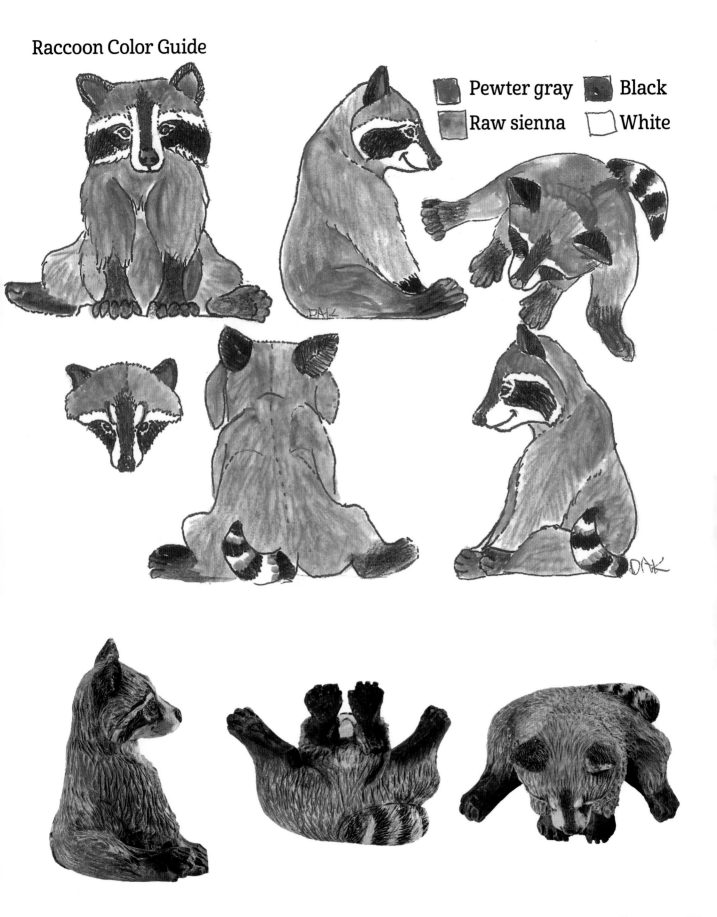

Pewter gray · Black · Raw sienna · White

Rabbit

The cottontail rabbit is a common long-eared critter that is a popular carving subject. These gentle animals symbolize spring. They are related to hares, though they are generally smaller than hares. With their long back feet, they can leap a great distance with just one bound.

A female rabbit is referred to as a doe, a male as a buck, and baby rabbits as kits. Baby rabbits are born helpless, blind, and without any fur. It takes about a week before they can open their eyes and hop. Rabbits are quite prolific. They can start breeding from three to ten months of age, are capable of producing eight litters of young annually, and may have as many as eight kits per litter. Typically, rabbits live from four to six years of age in the wild. In captivity, they can live up to twelve years.

More than half of the world's rabbits reside in North America, and there are forty-five different breeds of rabbits. The territories of rabbits are usually very limited—most spend their entire lives within about 1,300 feet (400m) of their homes. Of course, any rabbit will extend its range if there is a scarcity of food or if it is mating season. Rabbits can turn their ears 160 degrees, allowing them to pinpoint the exact location of a sound. They also have almost 360-degree vision, which helps them spot and avoid predators. Their teeth are very strong and never stop growing.

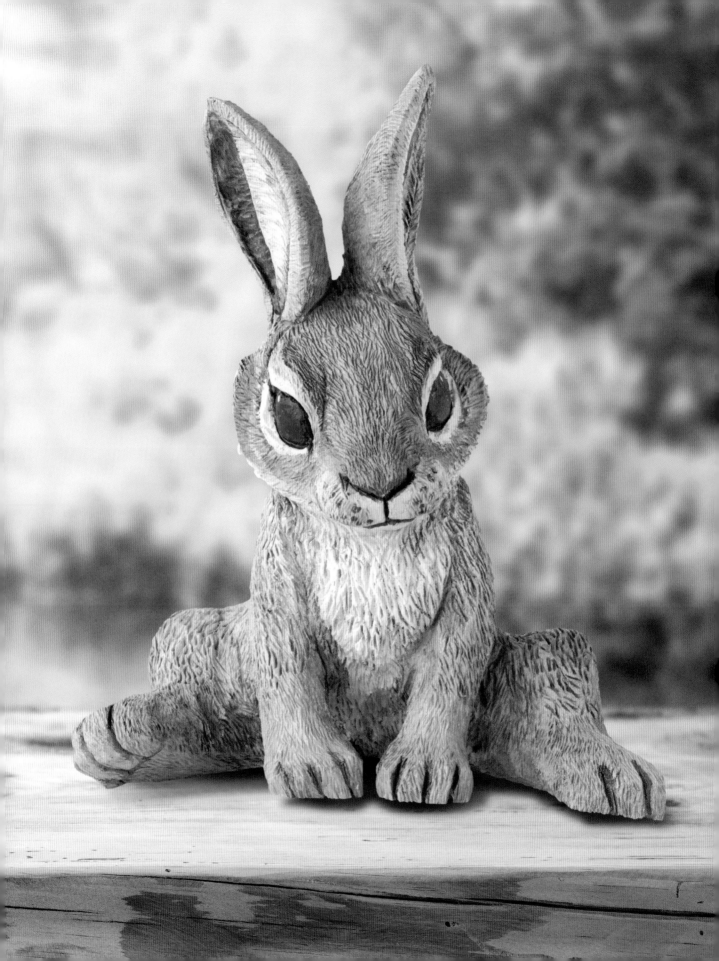

Texturing

- Tools: carving tools of choice (see page 29)

Either sand the carved piece or leave it as it is before texturing. If you choose to use hand tools, a #5, #6, or #7 gouge will work. If you are using power tools, a ball-shaped rotary bit will do the job.

First, draw the direction of the fur, using the hair tract pattern. With the tool you have chosen, apply pressure at contact at a thirty- to forty-five-degree angle. When the tool gets to the end of the area you have marked, ease up the pressure. Keep repeating this process until you have finished the entire rabbit.

Woodburning

- Tips: skew tip, writing tip, shading tip

Following the hair tract pattern, use a skew tip to outline the eyes and burn the eyeball. Outline the nose, cleft, and mouth with strokes. Again referring to the pattern, outline the white areas with fur-like marks and split the toes.

Using a writing tip and referring to the pattern, hollow out the ears and dot in the whisker dots.

Using a shading tip, fill in the rest of the fur, following the hair tract pattern. Remember to burn the back of the ears as well.

Painting

- Brushes: soft round brush, stiff-bristled brush, detail brush, toothpick
- Colors: burnt umber, burnt sienna, latte, white, black

After reviewing the color guide, prepare watered-down colors on your palette. Apply these to the rabbit using a soft round brush. Layer the colors until you reach your desired shades. Allow the piece to dry.

Next, use a stiff-bristled brush to drybrush white on the piece. Remember, don't water down the paint for drybrushing.

Use a detail brush to apply black paint to the eyes, nose, cleft, and mouth. For the whisker dots, use a toothpick. Put in a white highlight on the top of each eye with a toothpick. On the inside of the ears, paint in burnt sienna.

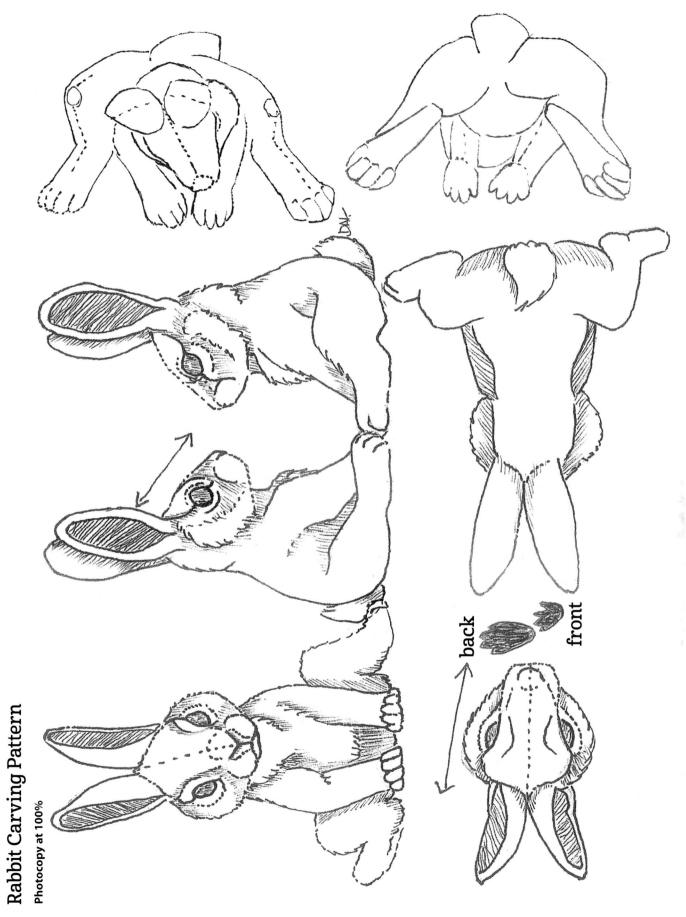

Rabbit Carving Pattern

Photocopy at 100%

back

front

Rabbit Hair Tract Pattern

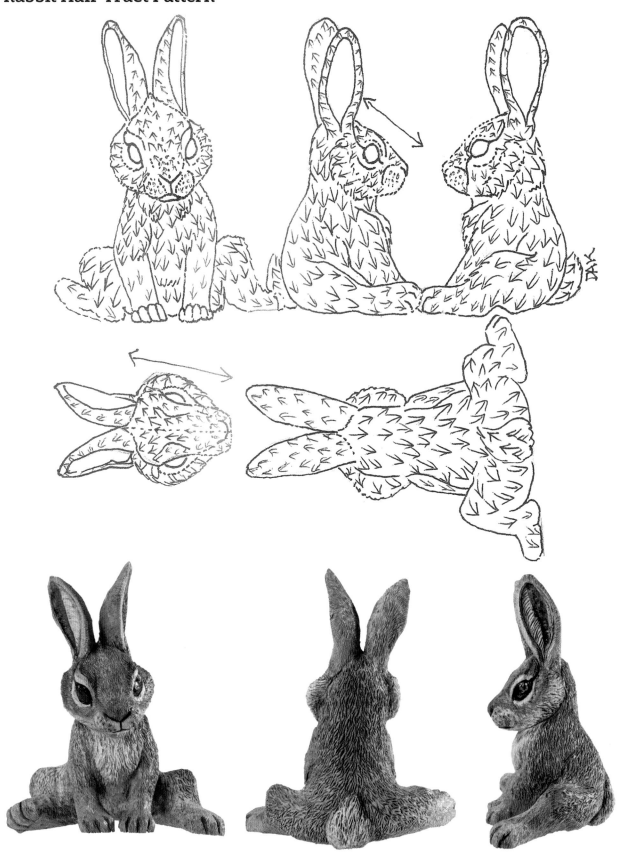

Rabbit Color Guide

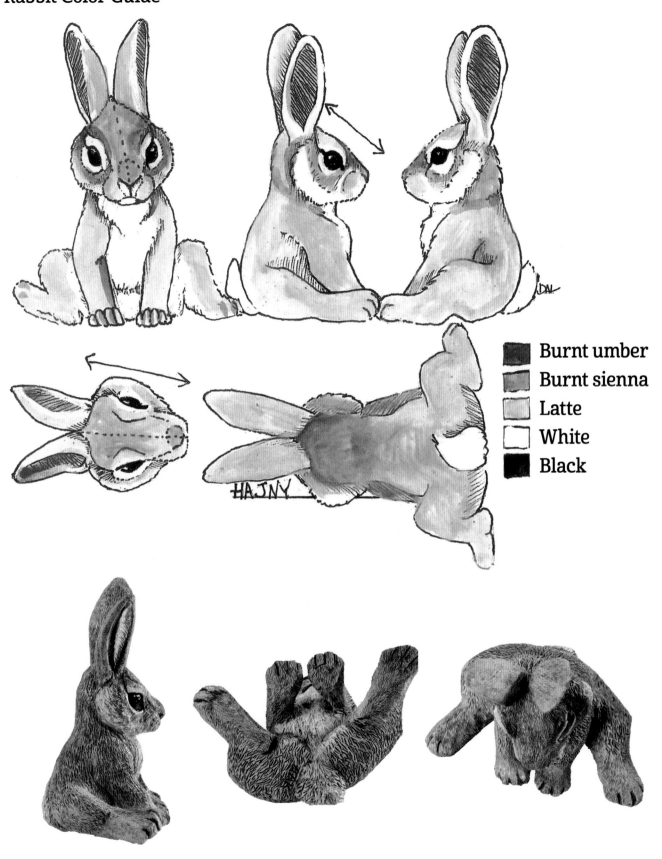

Burnt umber
Burnt sienna
Latte
White
Black

Panda

Pandas are roly-poly, beautiful black-and-white animals that symbolize China. They have specialized paws for grasping bamboo, with an additional pseudo thumb that holds the bamboo while the panda is eating. Many stuffed toy bears are modeled on these sweet animals.

Pandas have been on the earth for the past two to three million years. The first panda to live in the United Sates came here in 1936, but it was another fifty years before there would be another. Pandas live primarily in the central mountains of China, where they have access to the forests of bamboo that provide their food—although they are omnivorous, ninety-nine percent of their diet consists of bamboo. They have the second longest tail in the bear family, with only a sloth having a larger tail. A newborn panda is about the size of a stick of butter.

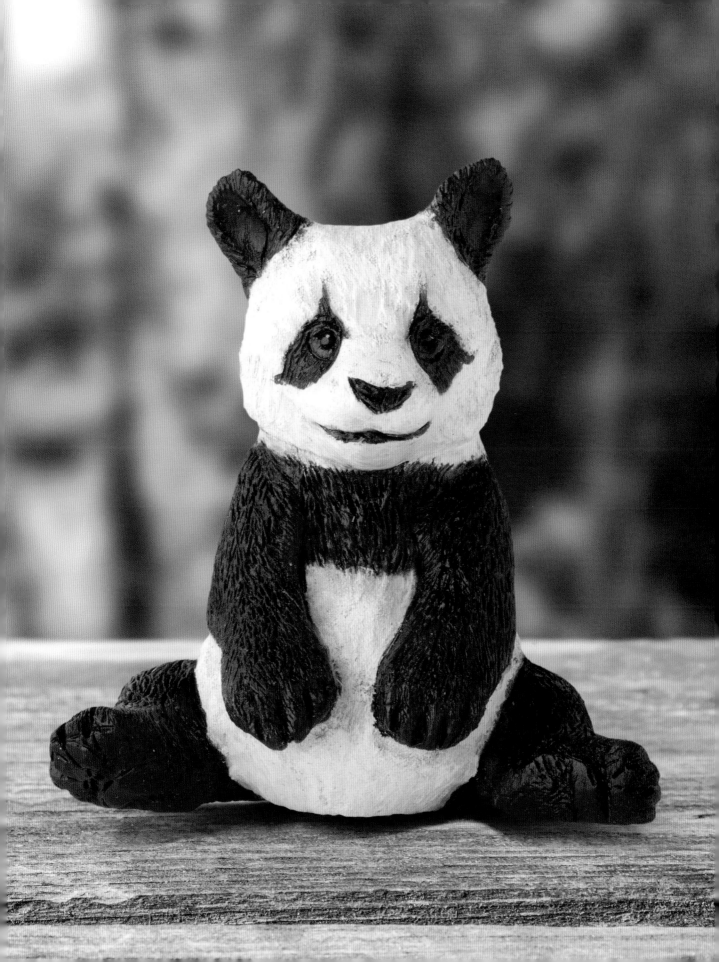

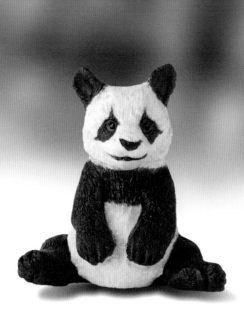

Texturing

- Tools: carving tools of choice (see page 29)

Either sand the piece or leave the cut marks intact before texturing. For hand tools, I recommend either a #5, #6, or #7 gouge. If you are using rotary tools, use a ball-shaped rotary bit.

Draw the direction of the fur, using the hair tract pattern. Apply whatever tools suit you best at a thirty- to forty-five-degree angle, applying pressure at contact. When the tool gets to the end of each marked area, lighten up the pressure. Keep this procedure going until you have finished texturing the panda.

Woodburning

- Tips: skew tip, writing tip, shading tip

With a skew tip, outline the eyes and burnish the eyeballs. Outline the nose pad, the mouth, and the eye patches, and then split the toes, referring to the pattern.

Hollow out the ears with a writing tip. Burn in the nostrils and squiggle burn the nose pad. Squiggle the pads on the bottom of the feet. For all these steps, refer to the pattern.

Using the hair tract pattern as reference, burn the dark areas with a shading tip.

Painting

- Brushes: soft round brush, stiff-bristled brush, detail brush, toothpick
- Colors: vanilla, burnt umber, black, white

Following the color guide, prepare watered-down colors on your palette. Using a soft round brush, layer the colors until you reach the proper shades. For the black areas, paint with the burnt umber first and allow to dry. Apply black on top of the burnt umber, but try to stay away from the white edges. Allow everything to dry before proceeding.

Use a stiff-bristled brush to drybrush white on the white areas. Drybrush the black areas with burnt umber. Remember, don't water down the paint for drybrushing.

With a detail brush, paint in the eyes, nose, mouth, and foot pads using black. Put a white highlight on the top of each eye using a toothpick. Refer to the color guide as needed.

Panda Carving Pattern

Photocopy at 100%

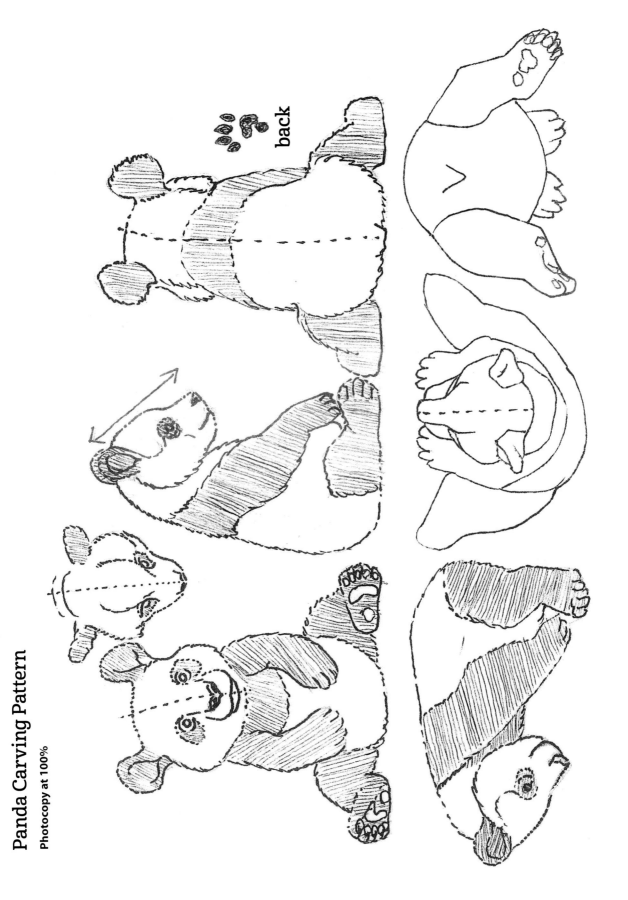

back

Panda Hair Tract Pattern

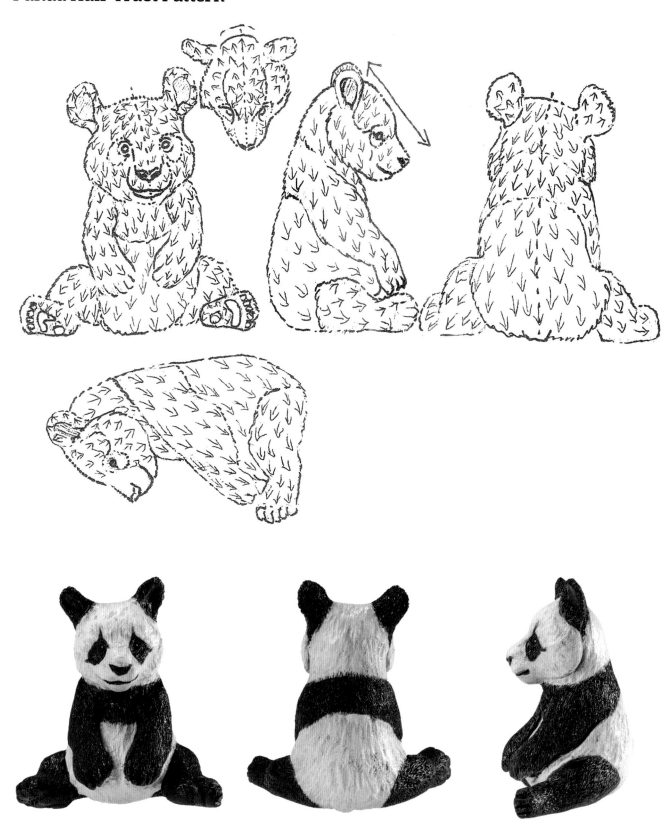

Panda Color Guide

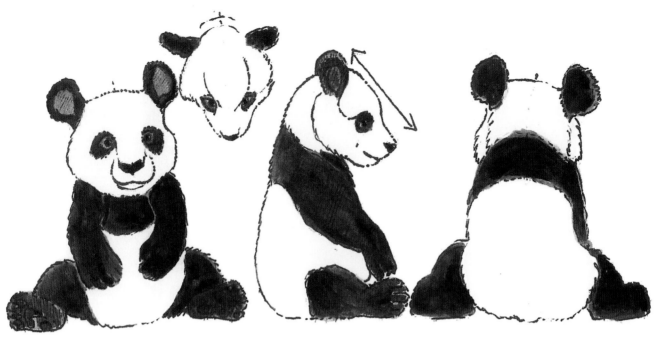

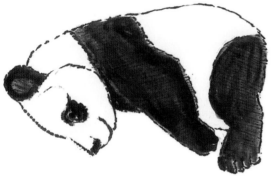

 Vanilla
 Burnt umber
 Black
 White

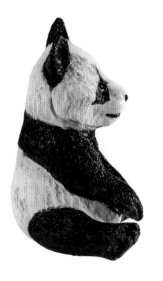

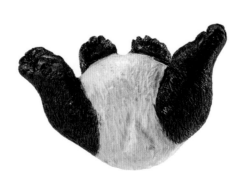

Study Boards

These study boards, or practice plates, have been used in my seminars for nearing thirty-five years. On each board, I have demonstrated texturing, woodburning, and painting techniques. Images of the woodburned version and the painted version, as well as a pattern, have been included for each board for you to use to practice if you're not yet completely comfortable with the burning and painting processes on your carved pieces done in this book.

These study board patterns can also be used for decorative purposes if you choose (see the sample photos opposite). For example, you can apply the designs to jewelry boxes, cigar boxes, canisters, or even gift boxes. Another suggestion would be to complete them, put them in frames, and display them as a kind of patchwork "quilt."

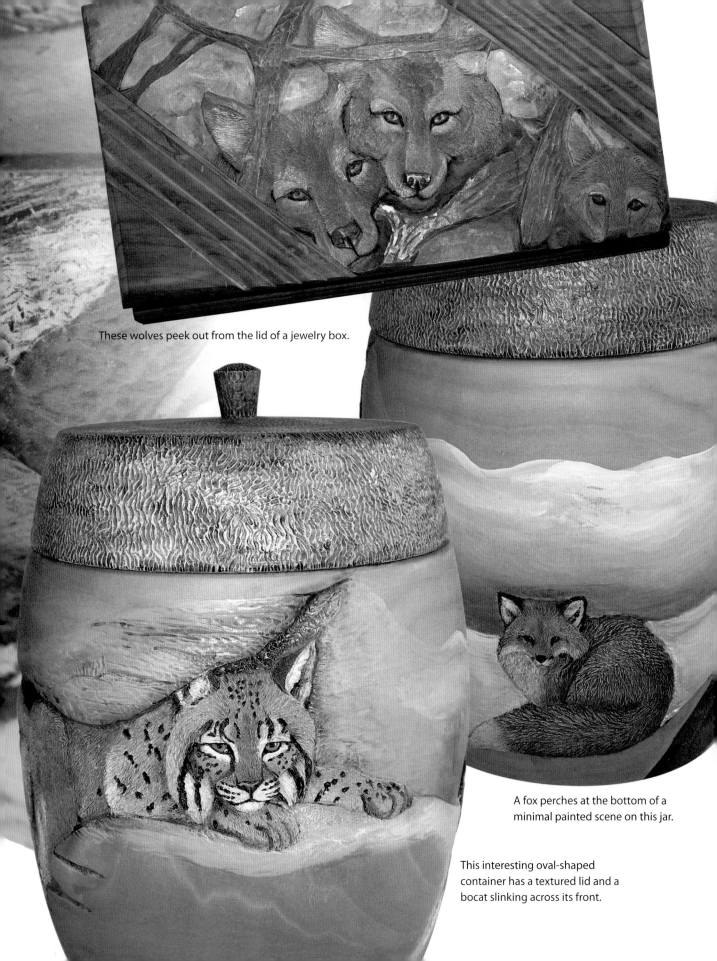

These wolves peek out from the lid of a jewelry box.

A fox perches at the bottom of a minimal painted scene on this jar.

This interesting oval-shaped container has a textured lid and a bocat slinking across its front.

Wolf Study Board

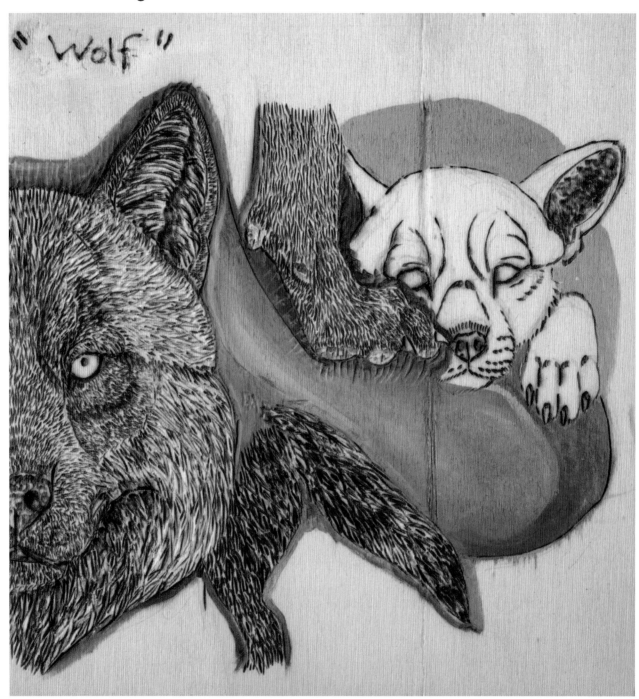

Wolf Woodburning and Texturing: Use a gouge or ball-shaped rotary bit over the heavy texture, then top off these areas with a V-tool or disc-shaped rotary bit. Break these areas down even further with a shading tip. For the pupil, nose pad, and whisker dots, use a writing tip.

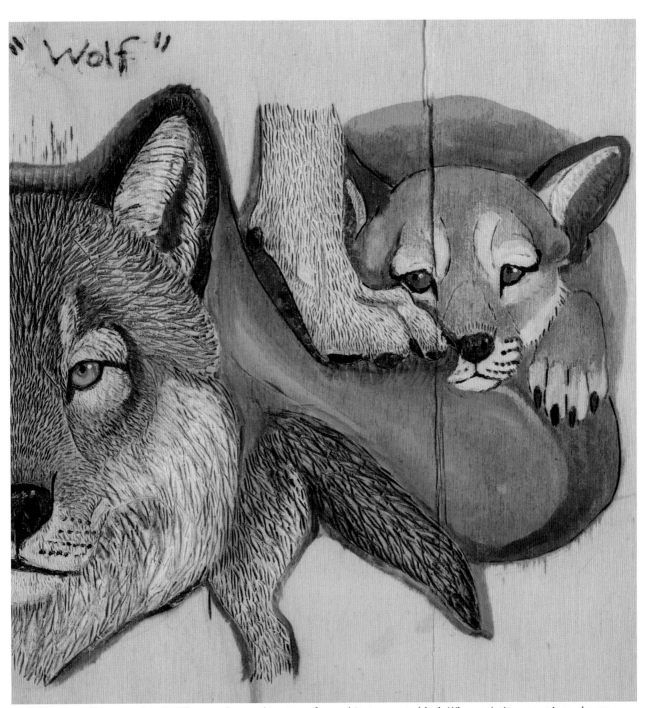

Wolf Painting: Wolves can be all different color combinations, from white to gray to black. When painting your piece, choose a picture of a wolf you like.

Photocopy at 75%

Otter Study Board

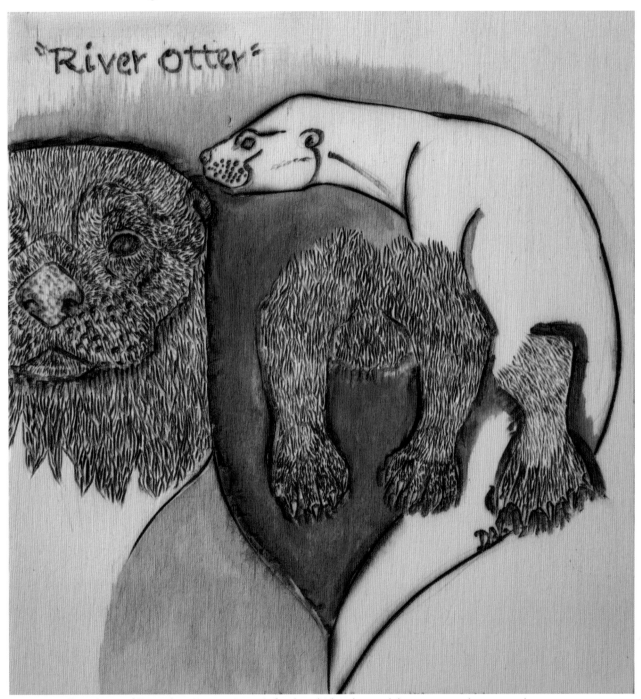

"River Otter"

Otter Woodburning and Texturing: Use a writing tip for the whisker dots and the texture on the nose pad.

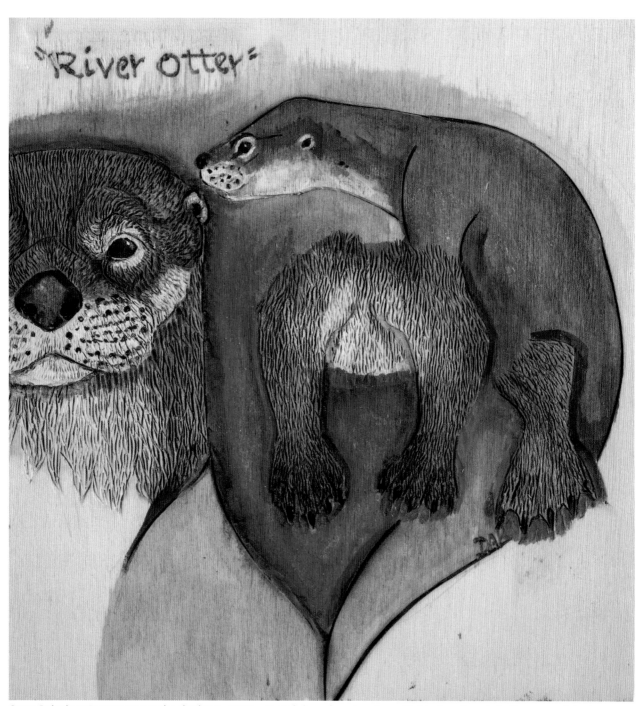

Otter Painting: For painting in the shadows, mix in watered-down burnt umber with black and apply to the areas of shade. Use a soft round brush.

Photocopy at 75%

Fawn Study Board

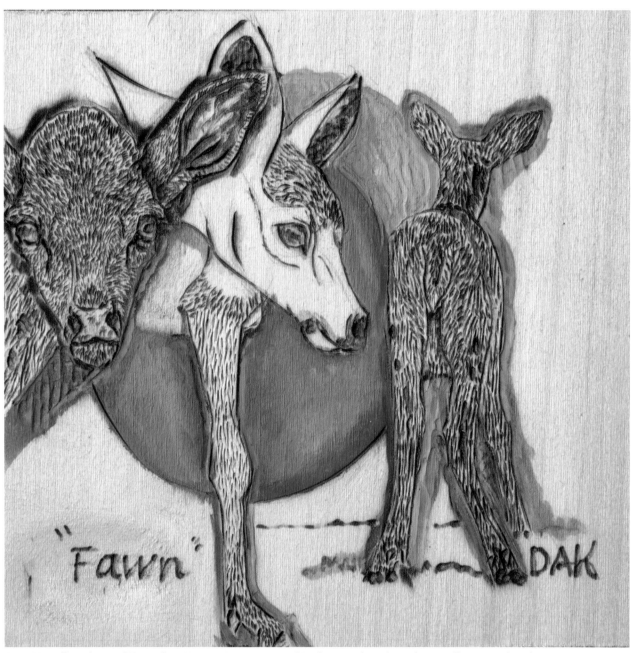

Fawn Woodburning and Texturing: Use a writing tip to mark in the nostrils and pupils, as well as to mark in the spots. Make sure you draw the areas first with a pencil.

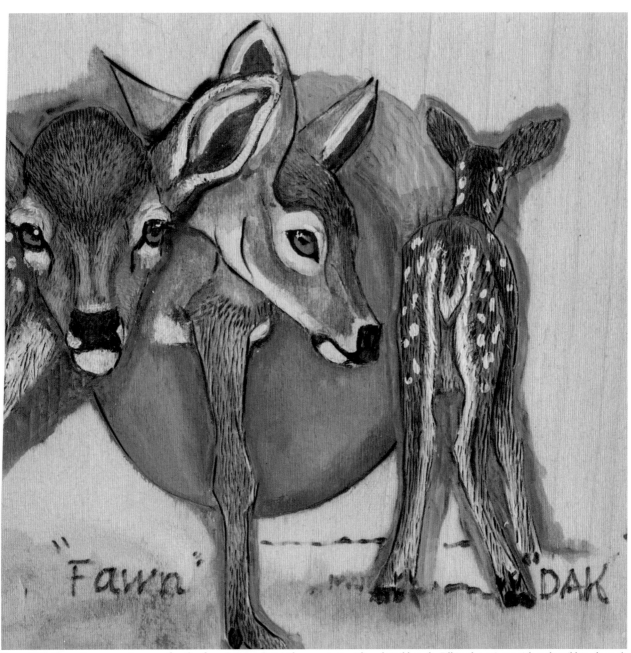

Fawn Painting: Use a pewter gray for the fawn's eyes. Paint these areas with a detail brush. Fill in the spots with a detail brush and a white (not watered down).

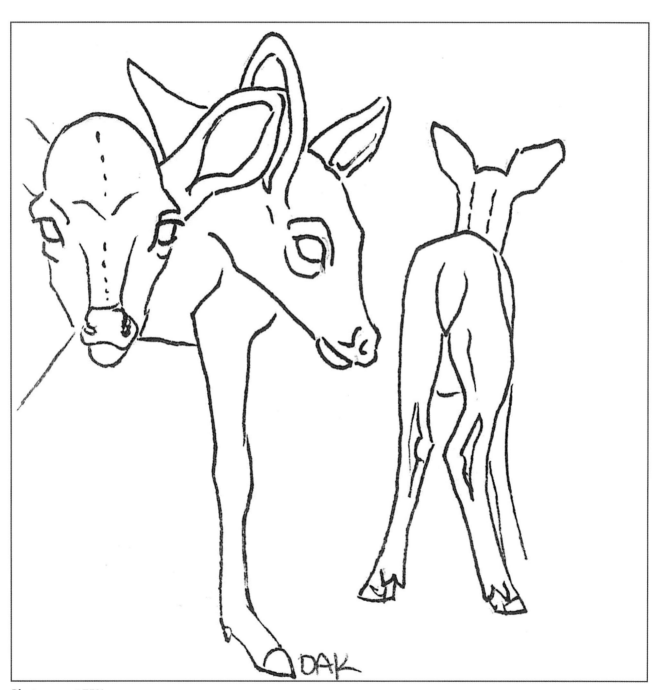

Photocopy at 75%

Kangaroo Study Board

Kangaroo Woodburning and Texturing: For the chest hairs, work with a writing tip to separate the locks of hair before burning the hair. This will give the illusion of a softer texture.

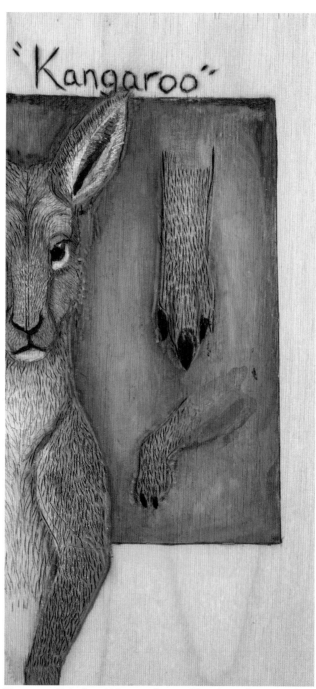

Kangaroo Painting: Using a soft round brush, apply a mix of a watered-down burnt umber and gray to fill in the shadows.

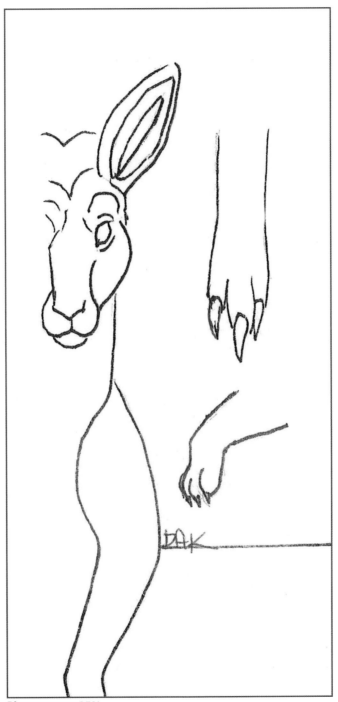

Photocopy at 85%

Elephant Study Board

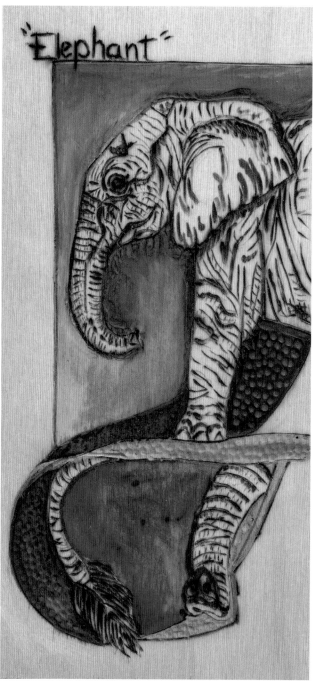

Elephant Woodburning and Texturing: Draw the wrinkles and follow the lines with a small veiner or ball-shaped rotary bit before you enhance the wrinkles by burning with a writing tip.

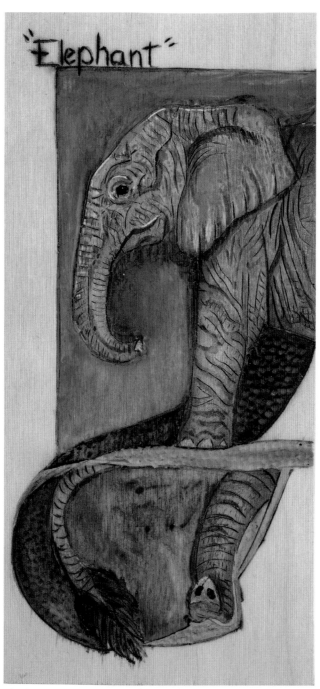

Elephant Painting: With a watered-down combination of burnt umber and gray, paint in the shadows with a soft round brush.

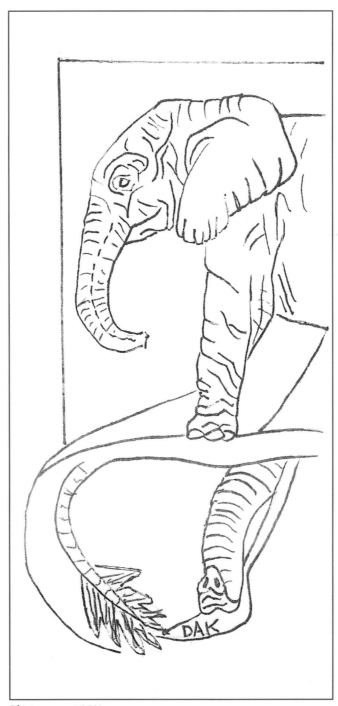

Photocopy at 85%

Fox Study Board

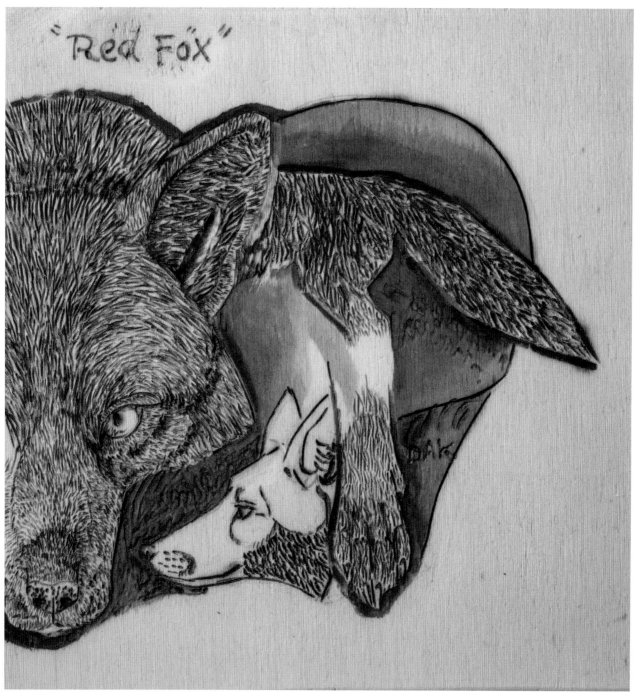

Fox Woodburning and Texturing: Enhance the texture with a gouge or round nose–shaped rotary bit, then enhance with a disc-shaped rotary bit or V-tool over the first textures you've done.

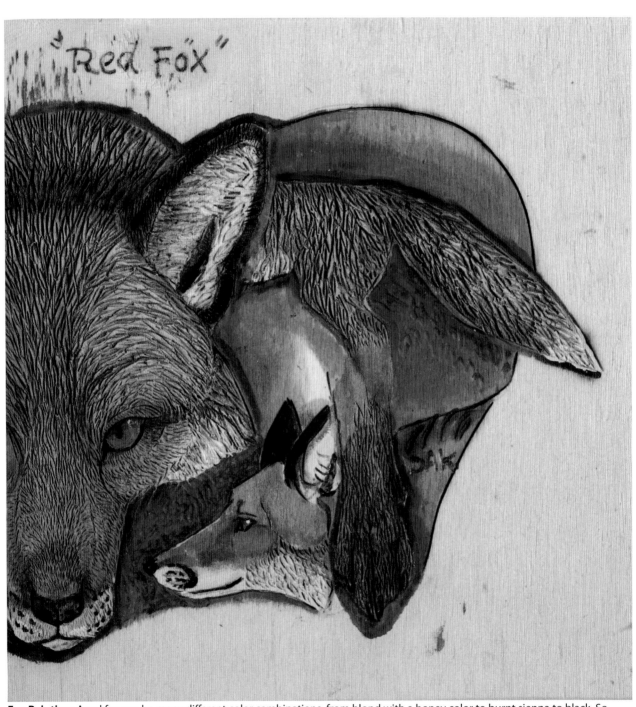

Fox Painting: A red fox can be many different color combinations, from blond with a honey color to burnt sienna to black. So when you decide to paint, use a watered-down burnt umber and the chosen colors for your shadowed areas.

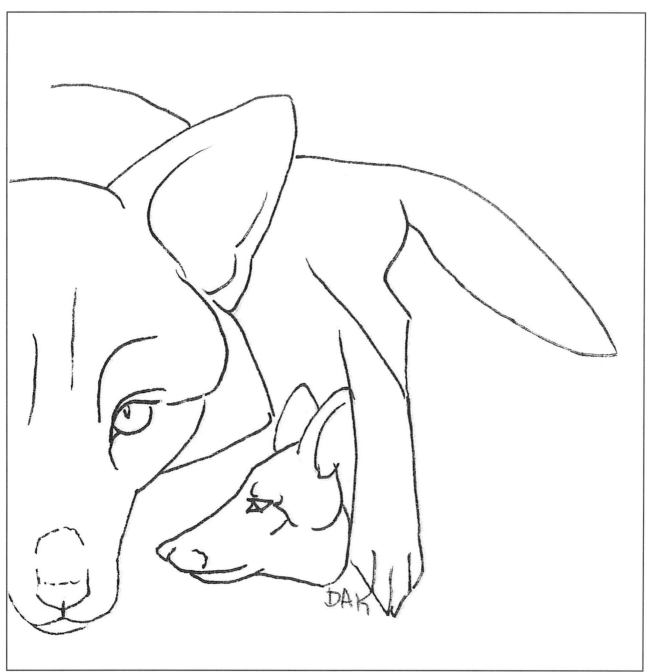

Photocopy at 75%

Chipmunk Study Board

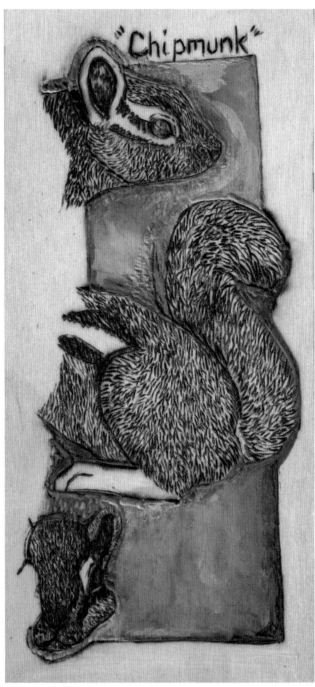

Chipmunk Woodburning and Texturing: Use a V-tool or disc-shaped rotary bit on the soft fur on the tummy, throat, and tail. For burning the stripes, use a writing tip. Pull the burner tip in the same direction as the hair flow using a stop-start, push in, pull motion.

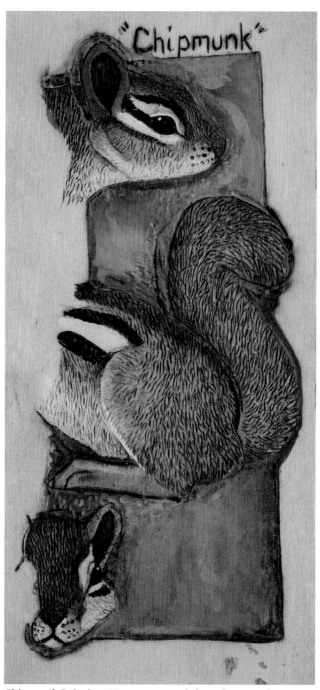

Chipmunk Painting: Using a watered-down burnt umber, paint in the shadows. Use a toothpick to paint in the whisker dots on the face.

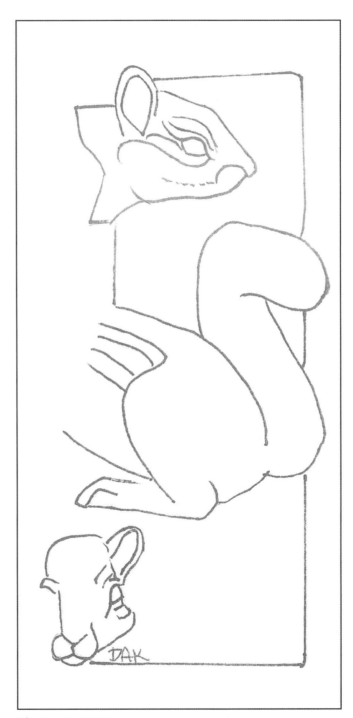

Photocopy at 85%

Bobcat Study Board

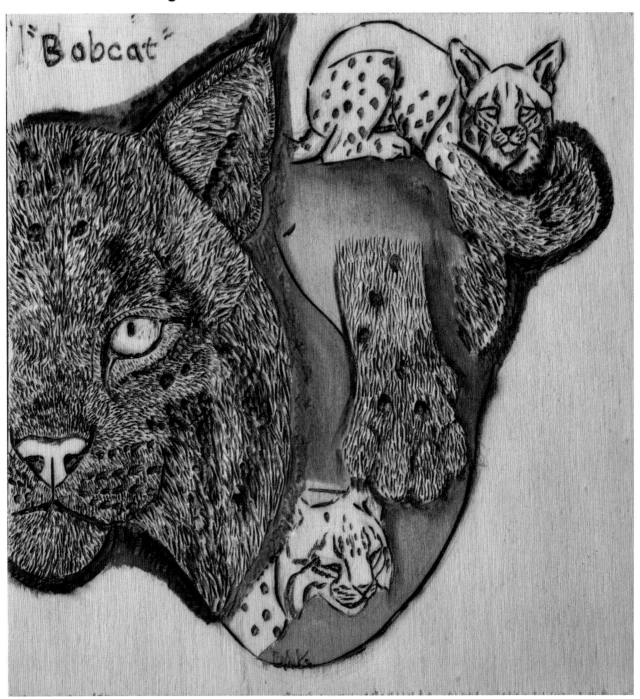

Bobcat Woodburning and Texturing: For the face, texture with either a disc-shaped or ball-shaped rotary bit or V-tool after gouging first. For burning the spots, use a writing tip.

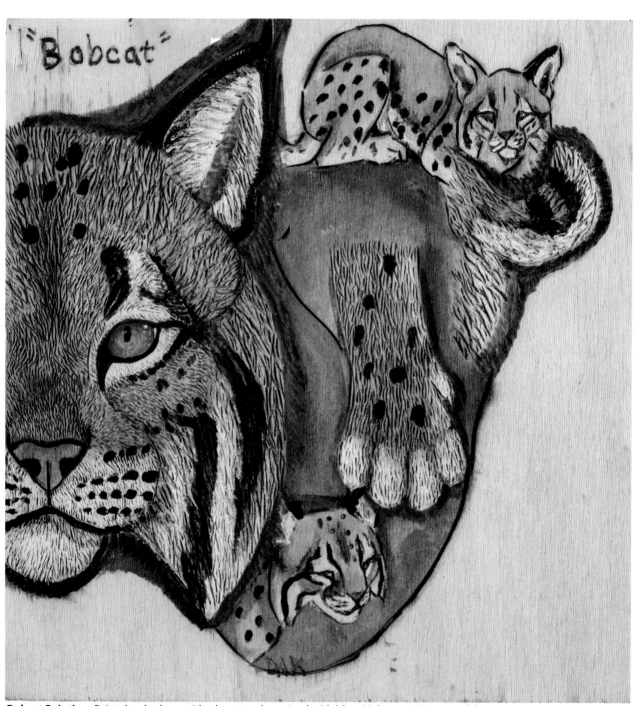

Bobcat Painting: Paint the shadows with a burnt umber mixed with blue. Make sure it's watered down.

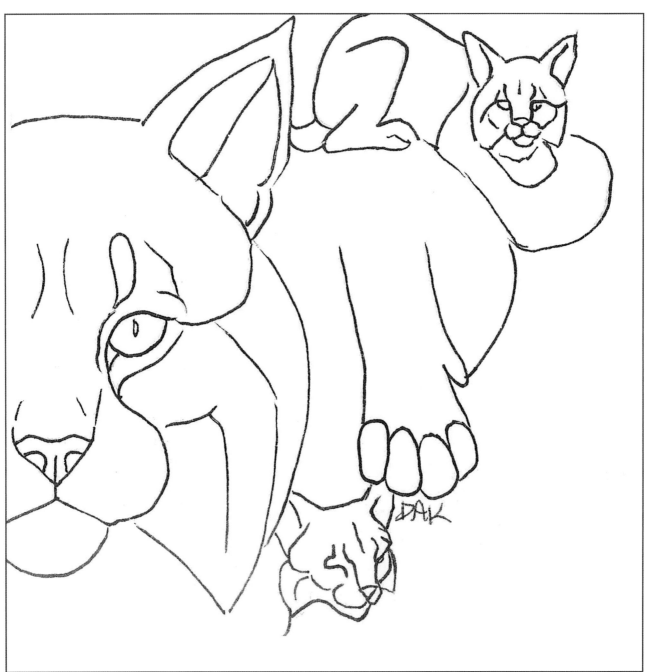

Photocopy at 75%

Donkey Study Board

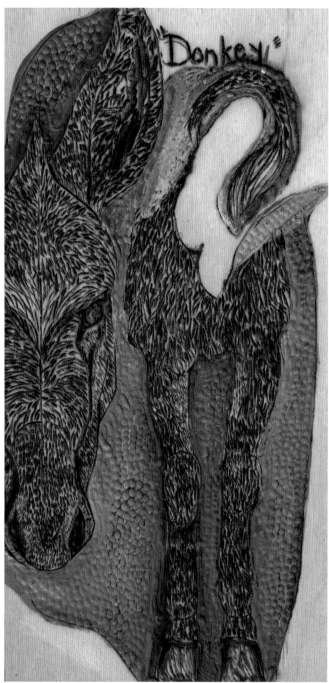

Donkey Woodburning and Texturing: If using a hand tool, use a #11 veiner, or use a ball-shaped rotary bit to first work in the texture. Then use a V-tool or disc-shaped rotary bit to enhance the texture.

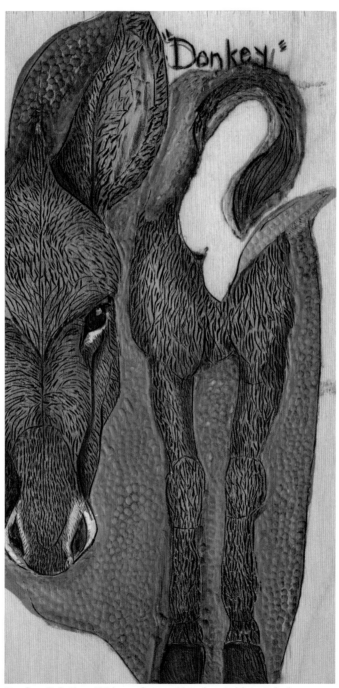

Donkey Painting: With a soft round brush, mix blue and a burnt umber that are watered down to fill in the shadowed areas.

Photocopy at 85%

Raccoon Study Board

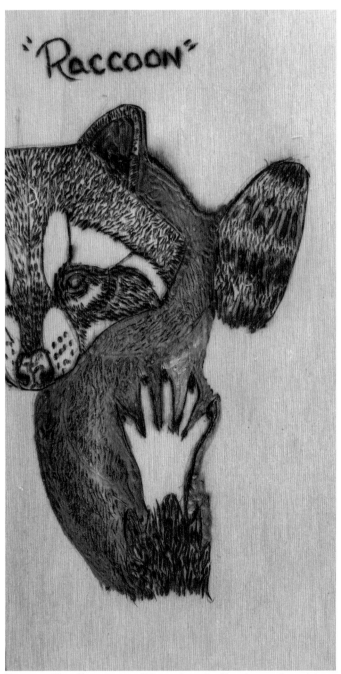

Raccoon Woodburning and Texturing: Outline the patches with a writing tip. Also use this tip to burn the inside of the ears, the whisker dots, the stripes on the tail, and the nose pad.

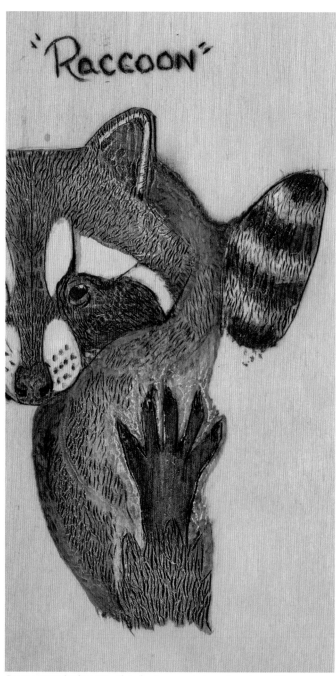

Raccoon Painting: For the shadows, mix burnt umber with gray and water it down. Apply this mixture with a soft round brush.

Photocopy at 85%

Rabbit Study Board

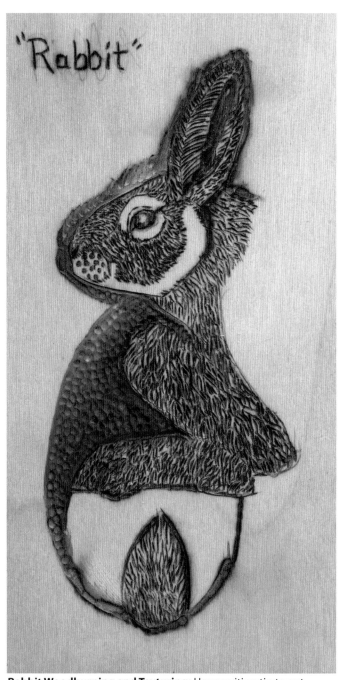

Rabbit Woodburning and Texturing: Use a writing tip to get the depth of the inside of the ears. When you do this, take the writing tip and rock it around for added illusion. You can also mark the whisker dots at this time.

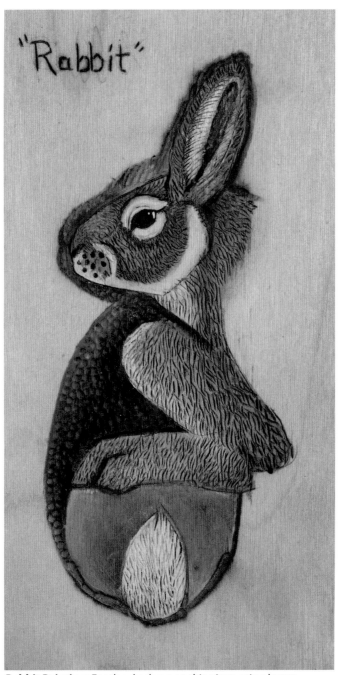

Rabbit Painting: For the shadows on this piece, mix a burnt umber and raw sienna that are watered down. Apply this with a soft round brush.

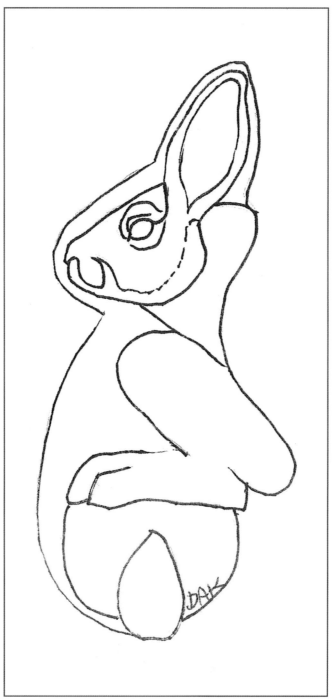

Photocopy at 85%

Panda Study Board

Panda Woodburning and Texturing: When burning the dark areas of the panda, make sure you turn the thermostat up on your burner.

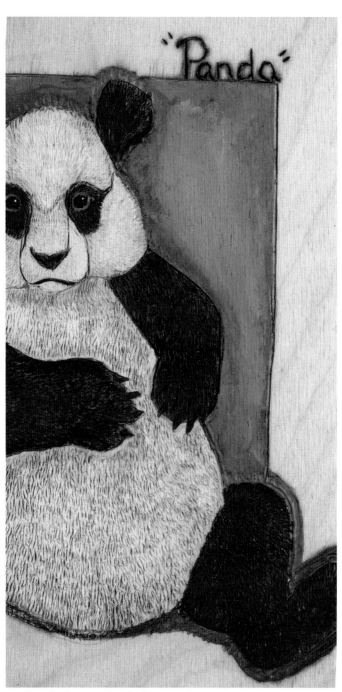

Panda Painting: For the shadows on the panda, mix together a watered-down burnt umber and gray. Apply with a soft round brush.

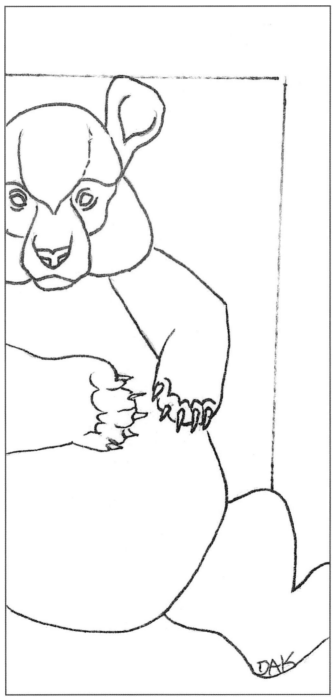

Photocopy at 85%

Advanced Examples

Where do you go from here? In the introduction, my main message to you was that everything you do in carving (as well as in life) is cumulative. Hopefully most things will be good, although there will always be bumps along the way. In this gallery, I've collected some photos of projects featuring the same animal subjects that are included in this book, but which are more involved and require more effort and skill in the areas of design and execution. These are to give you an idea of how to take the carving of a particular animal in this book to a more difficult, expert level. Challenge yourself to improve—the more you practice, the better you'll get. Hopefully the projects presented in this book will provide a springboard for you to continue to improve your skills in the future. Happy carving!

For this piece, I concentrated on the quick movements of the chipmunk and simplified the base. Chipmunks always seem to be on the move, and although this one is stationary for a moment, I wanted to give the illusion that it was ready to take off at a moment's notice.

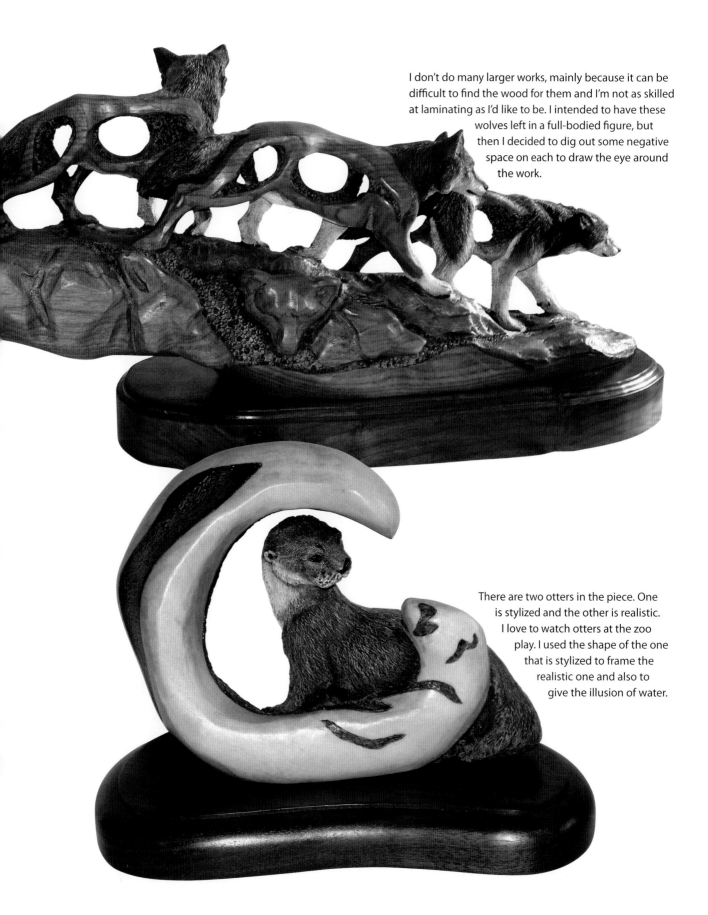

I don't do many larger works, mainly because it can be difficult to find the wood for them and I'm not as skilled at laminating as I'd like to be. I intended to have these wolves left in a full-bodied figure, but then I decided to dig out some negative space on each to draw the eye around the work.

There are two otters in the piece. One is stylized and the other is realistic. I love to watch otters at the zoo play. I used the shape of the one that is stylized to frame the realistic one and also to give the illusion of water.

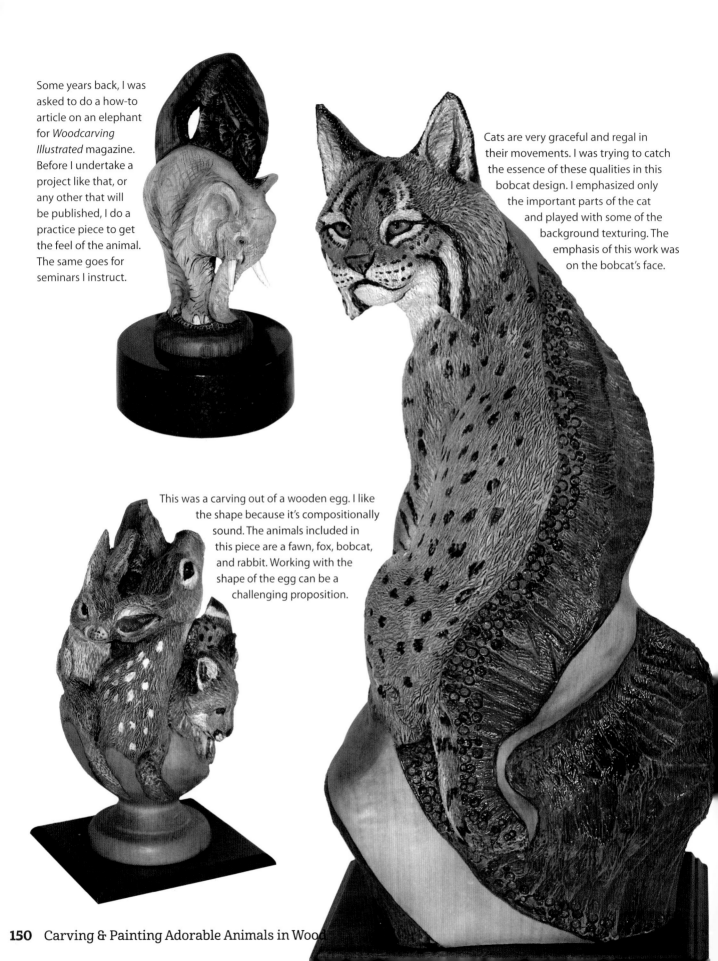

Some years back, I was asked to do a how-to article on an elephant for *Woodcarving Illustrated* magazine. Before I undertake a project like that, or any other that will be published, I do a practice piece to get the feel of the animal. The same goes for seminars I instruct.

Cats are very graceful and regal in their movements. I was trying to catch the essence of these qualities in this bobcat design. I emphasized only the important parts of the cat and played with some of the background texturing. The emphasis of this work was on the bobcat's face.

This was a carving out of a wooden egg. I like the shape because it's compositionally sound. The animals included in this piece are a fawn, fox, bobcat, and rabbit. Working with the shape of the egg can be a challenging proposition.

Acknowledgments

Thank you to all the kind people I've met through the years involved in carving. Your support has meant much to me, and lessons I've learned from many of you have served to be a valuable resource in my personal and professional growth.

Thank you to the family members who assisted us through this journey by reaching out and helping when we were in need of assistance. It was comforting to know that our son was in good hands when we needed someone to look after him when he was young and my travels necessitated being away from home.

Most of all, I want to thank my husband, Bernie, for always believing in me and for all of his work deciphering my notes. He organized all this information so I could remain creative. He not only typed all this, but he helped me woodburn all twelve projects in this book so I could concentrate on drawing patterns! That's the ultimate partner.

About the Author

Desiree Hajny's accomplishments in the woodcarving arts span thirty-five years as an author, teacher, commissioned artist, and competition judge. Desiree has won an amazing number of national and international awards for her carvings, including 26 best-of-show honors, more than 150 first place awards, 18 people's choice awards, and the *Woodcarving Illustrated* Woodcarver of the Year award, making her the first female to win the award. She is the author of nine woodcarving books, a contributor to seven others, and a contributing editor to woodworking periodicals across the United States and Europe. Desiree also creates commissioned pieces, which have included works for Disney Animal Kingdom and the National Forest Products Association. Her designs have also been reproduced and marketed in gift shops throughout North America by Mill Creek Studios in California. She lives in Blue Hill, NE, with her husband, Bernie. See more of her work at *http://hajny.fineartworld.com.*

Ordering Blanks

To order pre-roughed-out blanks for the carvings in this book, contact:
Peter Engler Designs
201 Commercial St.
Branson, MO 65616
(417) 335-6862
www.peterengler.com
Specify whether you are creating the rabbit, as the blank is a little bigger to allow for the ears.

Index

Note: Page numbers in italics indicate projects, and page numbers in bold indicate study boards.

Photo Credits

All patterns and drawings by Desiree and Bernie Hajny. All step-by-step photography by Desiree and Bernie Hajny. All finished project photography and tool photography by Mike Mihalo except the following: page 18 by Fox Chapel Publishing; page 22 by Lora S. Irish; pages 111 and 148–150 by Desiree and Bernie Hajny. The following images are credited to Shutterstock.com and their respective creators: pages 10–11, 30–31 (table background): S_Photo; page 12: Margo Harrison; page 13: John And Penny; page 14: Tobik; page 15: Cristina Jurca; page 16: Stephen Orsillo; page 27 (salted watercolors): beths; pages 32–33, 44–46, 56–58, 62–64, 74–76, 80–82, 92–94, 98–100 (backgrounds): S_Photo; pages 50–52, 68–70, 86–88, 104–106 (background): Viacheslav Voloshyn